Painting Flowers in Watercolour
with Charles Reid

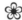

Wine and Blue Flowers—La Jolla
Watercolor on Fabriano Artistico
 Rough 140-lb. (300gsm) Paper
29" x 22" (74cm x 56cm)
Collection of Betsy Pedace

PAINTING
FLowers
IN WatercoLour

WITH
CHARLes REID

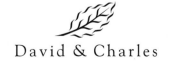

David & Charles

about the author

In my mind, Charles Reid is one of the best painters at work in the world today, and may possibly be the best teacher. His books are my best single source on drawing and painting. I have been an ardent fan of Charles Reid since I started painting just over twenty years ago and happened to buy one of his books. When I found that I could get into one of his workshops, I was one happy guy. The experience was even better than the anticipation.

On the first day, I was dreadful. But within days, quite literally days, Reid had me drawing and painting at a level that I never would have believed possible. Since then I have painted regularly, held three shows in a gallery near San Francisco and started to teach painting and drawing. Most of what I know and teach about painting has come directly from Reid. Furthermore, I find Reid's books indispensable to my own painting; I refer to them constantly. Almost everything I've learned in workshops is well documented and clearly illustrated in his books.

—Bob Waterman, Co-author, *In Search of Excellence*

Charles Reid is an award-winning artist specializing in watercolor painting. He is a popular workshop instructor whose other books include *The Natural Way to Paint* and *Painting What You (Want to) See* (Watson-Guptill Publications). He exhibits in both the United States and Europe. His paintings can be found in many private and corporate collections throughout the world. He is currently represented by the Munson Gallery in Santa Fe, New Mexico and Chatham, Massachusetts, as well as the Stremmel Gallery in Reno, Nevada. Charles Reid lives in Connecticut with his wife, Judy, and their cat Brutus.

Two videos of the same title have been produced to accompany this book. The videos are available from art and book shops or direct from Teaching Art, PO Box 50, Newark, Notts, NG23 5GY. Tel 44 (0) 1949 844050. Fax 44 (0) 1949 844051 or order online at www.teachingart.com

A DAVID & CHARLES BOOK

First published in the UK in 2001
First published in the USA in 2001 by North Light Books, Cincinnati, Ohio

A catalogue record for this book is available from the British Library.

ISBN 0 7153 1208 1

Printed in China by Leefung-Asco Printers
for David & Charles
Brunel House Newton Abbot Devon

Edited by James Markle and Marilyn Daiker
Cover designed by Amber Traven
Interior designed by Wendy Dunning
Production art by Ben Rucker
Production coordinated by Kristen Heller

275837

metric conversion chart

to convert	to	multiply by
Inches	Centimeters	2.54
Centimeters	Inches	0.4
Feet	Centimeters	30.5
Centimeters	Feet	0.03
Yards	Meters	0.9
Meters	Yards	1.1
Sq. Inches	Sq. Centimeters	6.45
Sq. Centimeters	Sq. Inches	0.16
Sq. Feet	Sq. Meters	0.09
Sq. Meters	Sq. Feet	10.8
Sq. Yards	Sq. Meters	0.8
Sq. Meters	Sq. Yards	1.2
Pounds	Kilograms	0.45
Kilograms	Pounds	2.2
Ounces	Grams	28.4
Grams	Ounces	0.04

acknowledgment

To my always encouraging and supportive editors and E-mail pals, James Markle and Marilyn Daiker, and to Vin Greco, my friend and photographer, who took the pictures in this book.

All artwork appears courtesy of the Munson Gallery unless otherwise indicated.

dedication

For Judith, Sarah, Peter and Brutus

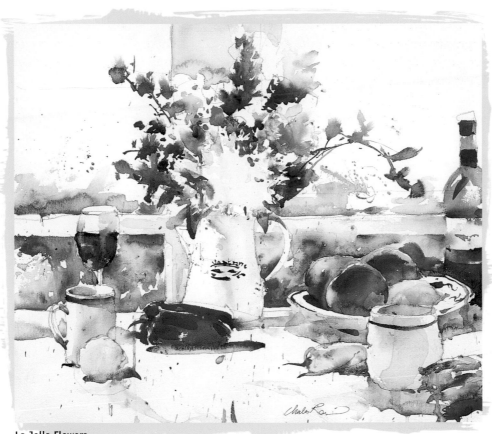

La Jolla Flowers
Watercolor on Fabriano Artistico Rough 140-lb.
 (300gsm) Paper
22" x 24" (56cm x 61cm)
Collection of Pat Dispenziere

table of contents

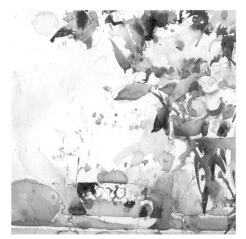

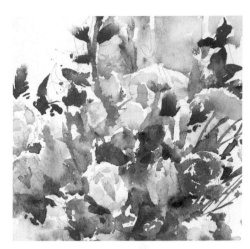

This section covers the essential tools and techniques I use when painting. I'll tell you about brushes and how to use them, how to mix and control your paint and the basics of composition and contour drawing. Read this section carefully and complete the exercises within it; they contain all the instruction you need to get started.

Simple compositions and learning the importance of local color-value are the basis for this section. Learn how to paint individual fruit, vegetables, leaves and flowers while keeping simple value contrasts. In these mini-demonstrations, you will practice the basic brush work and paint mixing that is essential to larger compositions.

Here's where we put it all together. I will walk you through seven different step-by-step demonstrations detailing the colors and techniques I use when painting.

Canvas Back
Watercolor on Fabriano Artistico
Cold-pressed 140-lb. (300gsm) Paper
41" x 30" (104cm x 76cm)
Collection of Judith Reid

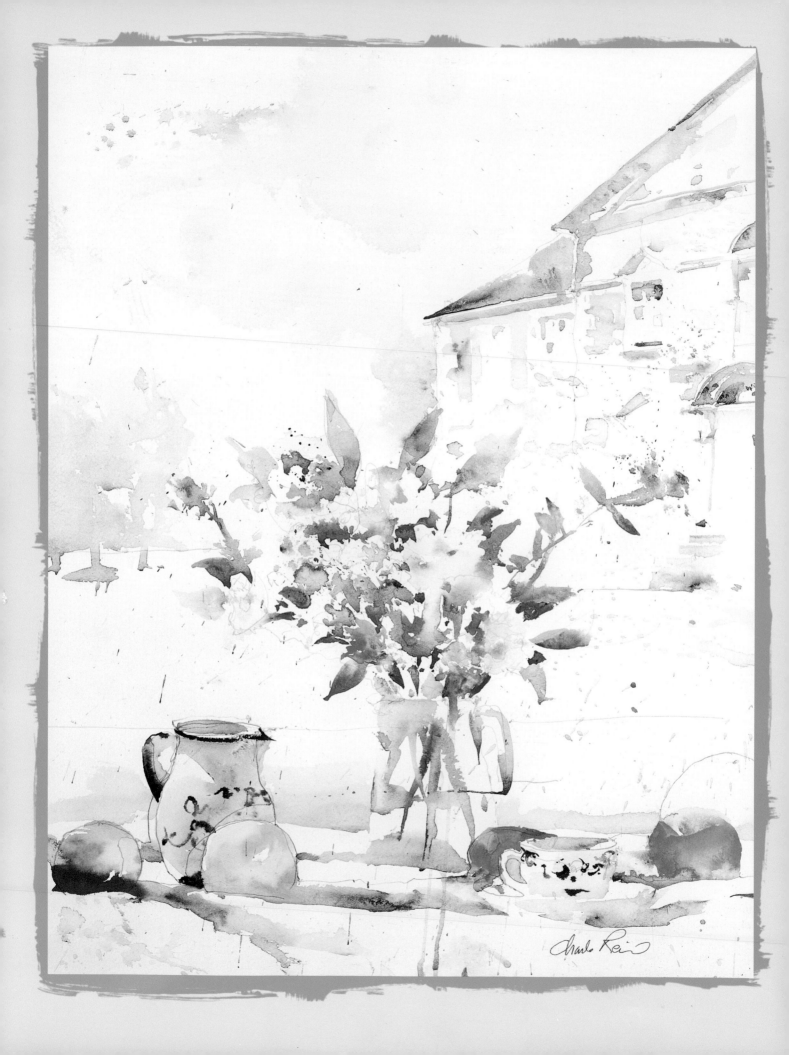

introduction

Photo credit: Barbara Smith

I was trained as an alla prima oil painter, working for a finish with the first try. When I started watercolor I adapted the new medium to my oil painting technique. My approach will seem foreign to those of you who are used to the traditional glazing and working from light to dark. My approach depends on painting mid and dark values with strong local color-value right from the beginning. My color and composition ideas are based on the Bonnard Principles: In color, work for a balance of warm and cool throughout your painting; in composition, avoid a focal point but work for both emphasis and lack of emphasis throughout your painting. This may sound confusing but hopefully all will become clear as you read this book and study my step by steps. I've also stressed the importance of seeing and thinking with the right, or abstract, side of your brain. This is a concept that's easily understood but very difficult to practice.

Concentrate on these basic ideas when doing the exercises in this book:
Keep it small.
Keep it simple.
Avoid overwashes.

Henry David Thoreau said it best; this is what my book is all about:

*"Our life is fittered away with detail…
simplify…simplify."*

Urchfont Manor
Watercolor on Fabriano Artistico
 Rough 140-lb. (300gsm) Paper
24" x 22" (61cm x 56cm)
Collection of Wendy and Terence Capp

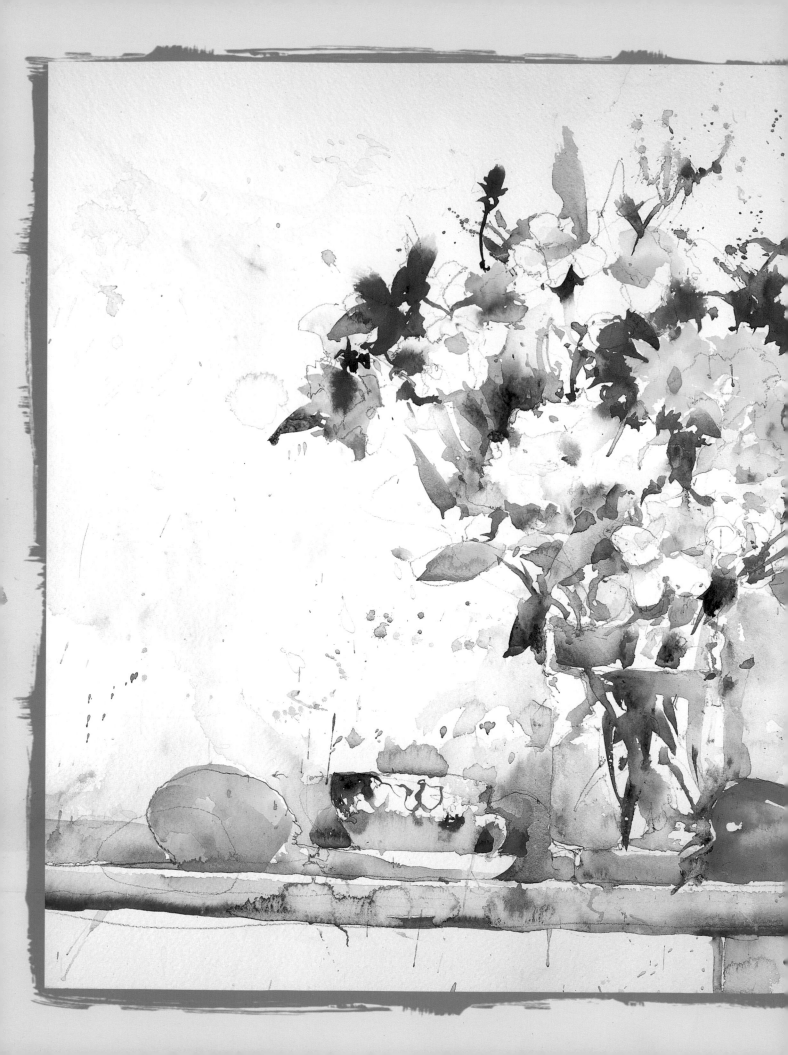

Getting Started

In this section I'll tell you about the materials I use. Then I'll show you my approach to brush work and color mixing. To conclude, I'll share some of my thoughts on composition.

If you have painted for a while, you'll have paper and colors you're comfortable with; stick with them. It's fun to experiment, but don't make paper and color changes that might cause unnecessary problems. The one element I strongly suggest is in your brush selection. Flat brushes won't work for you when practicing my demonstrations. You'll need good quality round brushes (sables if possible) that have spring and point well.

Economy is the key word in my approach to brush work and color mixing. Less is always better with one exception—you'll need lots of moist paint. The fewer the strokes and the smaller amount of color mixing, the fresher the painting.

A good composition should have the quality of a snapshot with the look of a happy accident. Too much time is wasted in arranging objects; instead, think only of an effective arrangement of vertical, horizontal, tonal and color shapes.

Urchfont Flowers
Watercolor on Fabriano Artistico
 Rough 140-lb. (300gsm) Paper
22" x 24" (56cm x 61cm)
Collection of Jan and Ian Wright

Brushes

Brushes are your most important consideration. You can use cheap paper, plastic palettes and student-grade paints, but you must have good brushes. There are four choices when choosing a brush: natural sable hair, squirrel hair, a combination of sable hair and synthetic fibers, and completely synthetic fibers. All of these brushes come in two shapes: rounds and flats. I use only round natural sable brushes (often labeled Kolinski after the little animal whose tail is used to make sable brushes). Although I'm not qualified to comment on the other brushes mentioned above (I've never used any of them), I will make some observations. You can't do the exercises in this book with a flat brush. Synthetic brushes are cheap, but they don't seem to hold much water and paint. A squirrel quill holds lots of paint and water but is rather lank and lacks spring, and is almost as expensive as sables. If you can't manage a natural sable, a round brush with a mix of natural and synthetic fibers would probably be your best bet.

Natural Sable Brushes. There are many fine natural sable brushes available. You can purchase them form any artists' catalog. Price isn't your best indicator of quality. My favorite is the da Vinci Maestro. It has a very full body and points beautifully.

A house brand no. 8 would be a good start. This is the size I use the most. Once you've made the plunge and have become accustomed to the cost, I'd backtrack and buy a no. 6. If you're delighted with your sable brushes, you should add a no. 10 to your next Christmas or birthday wish list.

Of course you'll also ask for a "travel brush" (see below). I use a no. 12, but you really don't need a sable larger than a no. 10. If you are painting a large area and need a big brush, use a squirrel quill or sable/synthetic brush. If you are unhappy with a sable, return it immediately for a replacement or refund. If your new sable doesn't seem to have spring—the fibers don't return to a point after a stroke—make sure you've loaded the brush with plenty of water and give it a shake. A merely damp sable will lack spring.

Travel Brushes. Isabey and Raphael make wonderful travel brushes. Each brush has a detachable metal sleeve that acts as a handle and case. Combine this with a half pan travel box and sketchbook and forget your camera.

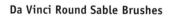

Da Vinci Round Sable Brushes
Here are my da Vinci Maestro round sable brushes. The da Vinci brush may come with a house brand label. Mine come from Art Xpress and have Art Xpress series 77 on the handle.
From left to right nos. 6, 8, 10 and 12.

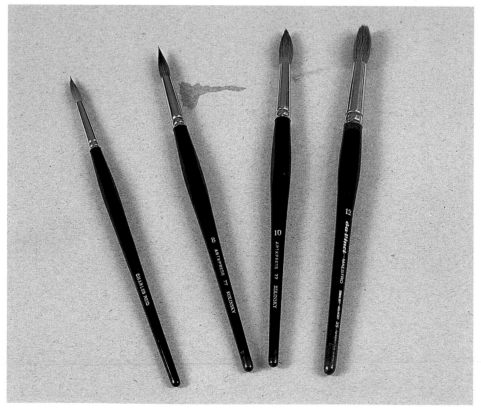

paper

Watercolor is different from oil painting. Oil painting is done on a passive surface. Canvas doesn't absorb paint. Each stroke stays the same unless the painter changes it. Watercolor painters work on a dynamic surface. Watercolor paper is alive and can paint parts of a painting with just a little direction from the painter.

Watercolor paper comes in three thicknesses or weights: 90-lb. (190gsm), 140-lb. (300gsm), and 300-lb. (638gsm). The best all around and the only one I use is 140-lb. (300gsm). Watercolor paper comes in three surface types. Hot-pressed (smooth) is fun to work with if you're an experienced painter. It's at its best with first-stroke painting but doesn't like

inexpensive paper

I've noticed that students do some of their best painting on cheap paper. Students also do best when they work small. I think working on a small piece of inexpensive paper makes the painting less of a production, and more of a relaxed, enjoyable painting experience. That's why carefully stretching paper with masking tape is a bad idea. It makes the paper and painting you're about to start too important. You only need to tape paper if you're sponging off sizing or working into predampened paper. Have several pieces of paper on hand, and be willing to discard a bad start.

corrections. Cold-pressed (moderate tooth or texture) is the most commonly used and the paper I'd suggest. Rough (pronounced tooth or texture) behaves the same as cold-pressed; it just has more texture. I suggest you buy a couple of sheets of each to experiment with.

Arches Paper. Most of my students use Arches paper. It's a durable paper that takes punishment, lifting and correcting in stride. I've never used Arches paper but this is a personal choice. My best recommendation is to stick with Arches or whatever paper you're used to.

Fabriano, Whatman and Waterford Papers. Several examples of what I think of as softer papers are Fabriano, Whatman and Waterford. They don't take corrections well, but they are very receptive to my "first-try/no-corrective-overwashes" way of working. I learned to paint watercolor on Fabriano as an instructor at Famous Artist's School, with the help of Franklin Jones, my supervisor. Frank was a direct painter who never told about glazes, I suppose, because the Fabriano paper we were using wasn't suited for overprinting.

I've never stretched since I've never used heavily sized paper and I always start with dry paper. I've always attached the corners of my watercolor paper to a board, with clips or masking tape.

materials

The brushes, paints and paper mentioned in this book are available from any quality fine art supply store.

My palettes are from
The Paint Box Co.
14 Park Crescent
Cuddington, Northwich
Cheshire CW8 2TY England
Phone/fax: 011 44 1606 882845

palettes

Palettes come in different shapes and sizes and have different well arrangements. A palette's wells are designed for squeezed tube color or for half pan, cake colors. Wells are the slots around the edges of some palettes and in the centers of others. The flat parts of your palette are your mixing areas.

Holbein Folding Palette. You really need a compact folding palette if you're going to paint outside of a studio. The original comes in a heavier gauge metal and is sturdy but expensive. There's a copy, made of aluminum, that is very reasonably priced and lighter. This palette has a thumbhole and is easily held in your hand. It must be carried flat as the wet paint will move about when travelling.

Craig Young Palettes. I paint every day and travel a lot, so my palettes take a lot of punishment. These handmade palettes from Craig Young in Britain are made of brass and hand-layered enamel. They are built for several generations of use. These are very expensive but beautiful.

Half-Pan Palettes . Half-pan palettes are wonderful for travel and sketching. The Winsor & Newton and the Daler-Rowney are the best made of the half-pan boxes and come with or without cake colors.

Cotman Field Box. The field box is inexpensive and has the advantage of a palette, water bottle and supply water container all in one unit. Half-pan colors are very concentrated, last longer than tubes and can be easily revitalized. Every painter should have a half-pan box, a sketchbook and a travel brush.

Square plastic tray palettes. Square plastic tray palettes are okay but only suitable for studio painting.

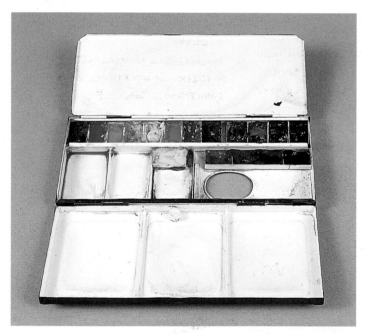

Palette Box

You must arrange your palette properly. Never squeeze a few haphazard colors into your mixing area. The colors on your palette must have an order so you know exactly where a color is without thinking. With practice, your brush will go to a color as naturally as your fingers go to a key on your computer keyboard.

Blues, reds, yellows and earth colors are placed in separate sections of the palette and arranged according to each color's value. I think of colors as belonging to families that merge into related families.

My palette (top, left to right): Carmine, Cadmium Red, Cadmium Orange, Cadmium Yellow, Cadmium Yellow Light, Raw Sienna, Raw Umber, Burnt Sienna, Burnt Umber, Oxide of Chromium, Olive Green and Ivory Black; (bottom, left to right) Cadmium Yellow Pale, Cerulean Blue, Cobalt Blue, Ultramarine Blue and Mineral Violet.

I like to mix my greens, allowing myself two slots for premixed greens. If I were painting a green that's cool, I'd use Viridian or Hooker's Green. If the green were neutral or grayish, I'd use Oxide of Chromium. If the green were warm, I'd use Olive Green.

ADDITIONAL SUPPLIES

Most of the people who come to my classes are serious painters but have families and careers and can't be full-time painters. Often they don't have studios and must pack up after a painting session. I do have a studio but do most of my still-life painting in our kitchen or in our little house in Nova Scotia. The materials I'm suggesting are what I use with mobility in mind. Please realize that my list is completely a matter of personal preference.

Spray bottle. You need to keep your paint moist while painting. Some colors dry before others and there will be colors you're not using much that may need a squirt. If you haven't painted lately, spray your palette a half hour before starting. Most colors will come to life unless you haven't painted for months. If colors have turned to little chunks, they can't be brought to life and must be discarded.

Battery-powered pencil sharpener. These are fast and efficient but annoying to others. You need a sharp pencil for contour drawing.

Clips to secure your paper to a board. Black bulldog clips with folding handles are handy when packing your work in a portfolio.

Kneaded eraser. Common erasers often disturb the paper. I use a Design kneaded rubber eraser. These erasers clean smudges as well as erase lines. Make sure your eraser is clean.

Pencils. Use sharp graphite pencils; HB, B and 2B are fine. I also use regular 2B office pencils. Avoid charcoal and carbon pencils since they tend to smudge.

Masking tape. Use tape for stretching paper when starting with wet paper. I don't stretch wet paper so I only use masking tape to secure the corners of my paper to my board if I have forgotten my clips.

Pocketknife. If you're using a watercolor block, you'll need a small pocketknife to remove paper from the block. In emergencies, I use a knife tip to carefully scrape out small mistakes and highlights.

Water containers. I attach my water containers (I use Holbein's) to the metal loop on my folding easel. You'll have to use some ingenuity to find a water container that you can fit to your easel. Snap clamps from your hardware store may work. Each easel will need a different solution, but you should work out a system that allows you to have your water, palette and picture within inches of one another.

Drawing board. Make sure your drawing board is a good size for you to handle.

Easel. A collapsible metal easel is your best bet. I've not used a metal easel, but there are several I've seen in my classes that are light and sturdy. It would be best to check with painting friends to find an easel that works best for them.

buying paint

I primarily use Winsor & Newton and Holbein watercolors as well as Sennelier, Schmincke and Old Dutch. You'll see price variations between these makers but all have equally high standards regarding permanence and rate their colors honestly, often in four categories, from permanent to fugitive.

Colors do vary from one paint to another. You can't be sure that one maker's Cadmium Yellow or Cerulean Blue is exactly the same temperature and value as another maker's.

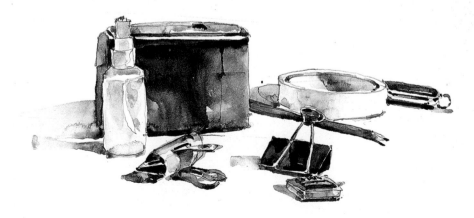

Tools of the Trade
Here are just some of the items you will need before you begin painting.

brush work

A good brush is essential to painting in watercolor. But even more important is knowing how to use it. These illustrations will help you become a master of the brush. Practice these techniques to enhance your painting.

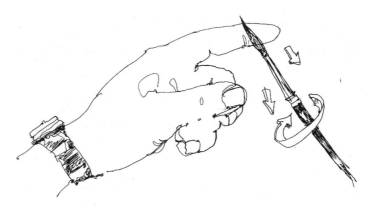

Round Brushes
You'll be using round brushes. Your brush should have a sharp point. Wet your brush, give it a good shake and draw the body and tip of the brush across your index finger. Rotate the brush at the same time. The brush should come to a point.

The Tip of the Brush
You'll need several brushes that point. If your brushes don't pass the "pointing test," go to the section on brushes (page 12). You can't paint flowers with a blunt and tired brush.

 Blunt tip (top): This is how watercolor brushes look when the tip is stroked over the paper. You mustn't stroke the tip of a round watercolor brush over watercolor paper. Watercolor paper is like sandpaper to a delicate brush tip.

 Sharp tip (bottom): This is the way a damp brush should look.

Things to Remember
Don't paint with the tip of the brush; you'll ruin the point. Always paint with the body of the brush. Don't stroke and lift; keep your brush on the paper until you've finished a shape or have run out of paint. Don't paint with a floppy wrist. Your wrist should be firm but not rigid. Paint with your hand, wrist and forearm.

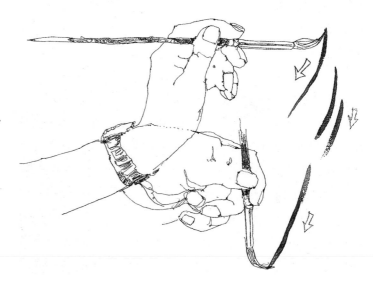

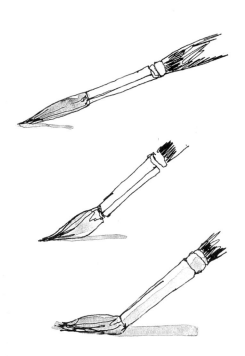
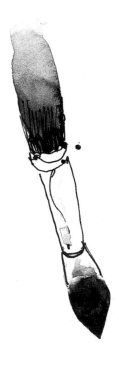

You Can't Paint With Dry or Semimoist Paint

Many people use too much water and not enough paint, often because their paint isn't wet. The colors in the wells must be wet. You should be able to stick the tip of your brush into the paint. Your brush should never just pass over the surface of a color in the well. You'll just be painting with water.

Basic Brushstroke

Any round brush will do to practice your brush work. Wet and shake your brush. Start with the tip of the brush and immediately press your brush against the paper, almost to the metal ferrule. This is correct brush position. You should always paint with the body of the brush, never with just the tip.

A Round Watercolor Brush Is Designed to Form Shapes

When the brush is pressed, stroked and lifted abruptly, you'll have a darker color value and harder edge at the beginning of the stroke and a lighter color value and softer edge at the finish. The tip and sides of a round brush are designed to form shapes.

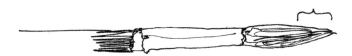

Load Your Brush With Color

After rinsing and shaking your brush, load it with color from the tip to about a third of the way up the body.

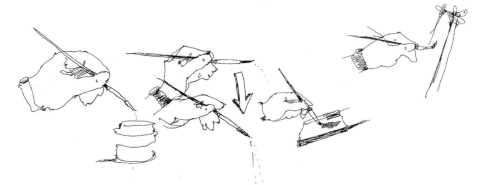

Never Go Back Into a Wet Wash With a Watery Brush

Sometimes a color or value looks wrong and the painter attacks it with a wet brush. This is usually disastrous.

Water, Shake, Palette, Paint

Remember these four words; they'll remind you of steps you can take to assure success: *Water*—rinse your brush. *Shake*—shake your brush to lose excess water. You'll need newspaper on the floor. If you're worried about your floor, you can pass your brush across a tissue, paper towel or piece of cloth towel. Don't blot your brush; it'll remove too much water. *Palette*—you should be taking paint to your picture, not water. Ninety-five percent of the time you should be picking up paint after a rinse and partial dry. *Paint*—put the brush to your painting.

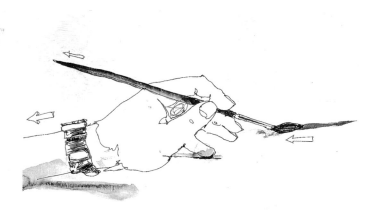
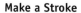

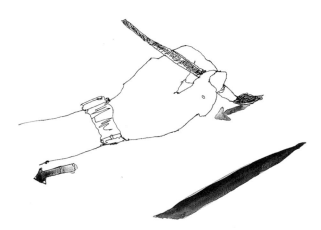

Make a Stroke

You'll need water, a no. 8 round brush, a palette and any dark, moist paint. Remember: water, shake, palette and paint. Place the brush's tip. Start pressing the brush, and at the same time, start moving your hand. Make a stroke about 4" (10cm) in length and lift in one fluid motion.

Controlling Your Brush for an Accurate Stroke

Making accurate, specific shapes is necessary in flower painting. Touch the tip of your little finger to the paper.

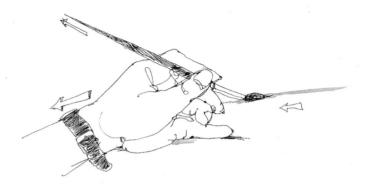

Controlling Your Brush for an Accurate Stroke
Rest the side of your hand on the paper as you make a stroke.

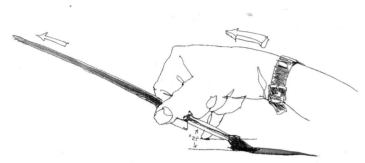

Stroke Up From the Bottom
Always start your stroke where you want the darkest color value. (Your brush is fully loaded at the beginning of a stroke.) Place the tip of your little finger on the paper, bend and lock your wrist. Press the brush into the paper and make an upward stroke, pushing with your upper arm.

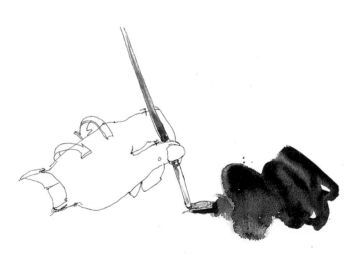

Painting Large Areas
You should usually hold your brush at about 45°, but when painting larger areas, hold the brush at 75° or 80°. Press the brush almost to the metal part. Make a zigzag stroke by rolling your wrist back and forth. Don't lift the brush until you run out of paint.

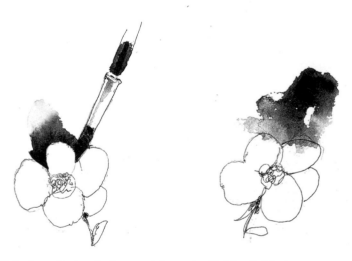

Painting a Darker Background Around a Lighter Subject
Start your stroke where you want the darkest value and the firmest edge. The tip finds the boundary of the white flower, presses and then paints around the flower and works into the background. The brush is held at right angles to the flower boundary. If you start in the background and paint toward the flower, you will make a fuzzy edge and a lighter value.

Learn Brush work painting a coot

I have a collection of decoys and often include them in my paintings. In this exercise, I'm painting a coot (a generic name for a variety of sea ducks). You'll be painting rich darks with the first try with no overwashes. You'll need moist paint and nos. 8 and 10 round sable brushes. Hopefully, you've set up your palette with your dark blues, earth colors and black in order and near one another so you won't have to search for the color you want.

I've used mostly blue and black for my decoy. I can't have a totally cool bird so I've used some Burnt Sienna or Burnt Umber in a small section to use with the blue. This adds some warmth that can tie in with adjacent warm areas in the still life. The coot is 4" x 7" (10cm x 18cm).

I'll concentrate on brush work in this demonstration. You'll see that I paint a section, lift my brush and mix a new rich dark swatch. Then choose a new starting point and paint back, meeting up with my previous section. This approach is critical in keeping rich darks in the first try. You won't be glazing with a second overwash. Read through all of the steps before attempting this exercise. You'll be painting the entire bird wet-in-wet. It's no easy feat. Don't worry if some parts dry before you can make a blend. Just try to avoid watery, wimpy washes. Get lots of paint in your mixes and try for good shapes. If you can do this, I'll be happy.

This is a complex and difficult exercise with too much to think about. Do the best you can and be glad for small victories. Students complain that areas dry too fast. I think this is because students separate and paint one thing at a time.

colors

Burnt Sienna • Burnt Umber
Cadmium Yellow Light • Cerulean Blue
Ivory Black • Ultramarine Blue

brushes

Nos. 8 and 10 round sables

the prince of colors

Black is called "the prince of colors." I'll use it in my coot demonstration, along with some other darks.

Black has been present in painting since the sixth century B.C. in Egyptian and Greek art. I've checked through my art books and found black present in painting through the centuries, right up to my use of black in "Coot Painting." Black has been given a bad reputation probably because students have tried to darken colors with black or diluted it to make grays. Black should only be used as a dark, and it should only be mixed with other dark colors at their darkest values.

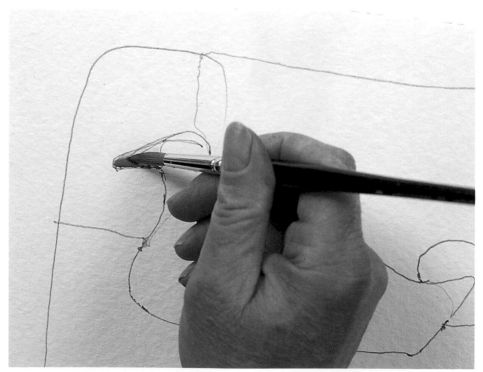

1. This gives you a close-up of how to hold the no. 8 brush. The side of your hand is resting on the paper. Place the brush tip at the tip of the bill and press the brush to its midsection. Use Cerulean Blue and water.

2: The midsection of the brush is wet with a mixture of Cerulean Blue and water so when you lift the brush, there's a path of moisture for the color in the bill's tip to follow.

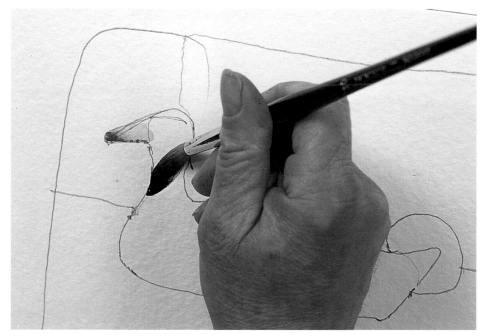

3: Load your brush with a mixture of Ultramarine Blue and Ivory Black. Start your new stroke at the front of the coot's neck. Paint up, using the tip of the brush, carefully describing the shape of the coot's chest.

4: Paint up to the bill. Some water from the bill will seep down into the neck. But if your blue-black mix is thick enough, you should be OK. Continue up but now leave a thin strip of dry white paper to keep a hard edge between the head and upper section of the bill. Continue up and around the head leaving white for the eye. Paint down to complete the neck.

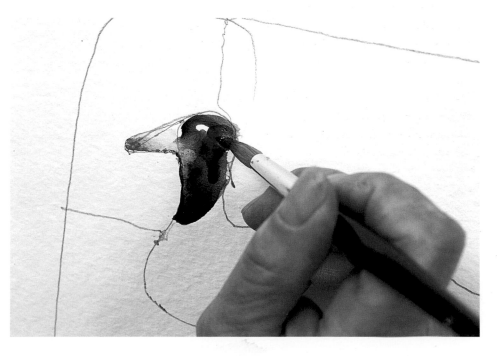

5. Reload your brush with the blue-black mix. Place the brush tip at the front of the chest, press and paint up to meet the neck.

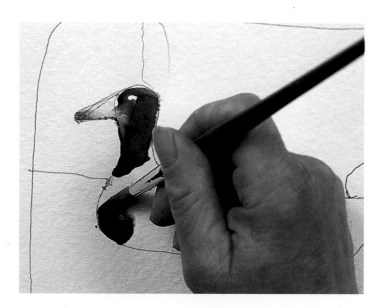

6. Switch to the no. 10 brush. Paint a section in the upper right part of the coot's back with Cerulean Blue (no black). Reload your brush with your blue-black mix. Start your stroke at the tail. Paint to the left under the blue section and form the aft section of the bird.

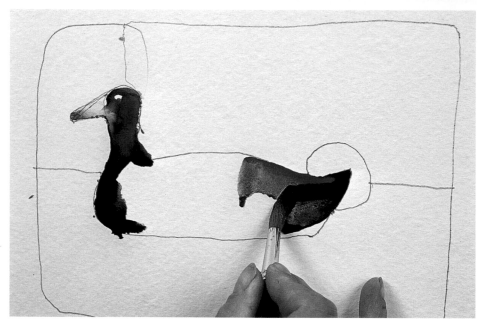

7. Without lifting, continue with your blue-black mixture toward your left making a gentle convex curve for the coot's back until you reach the neck.

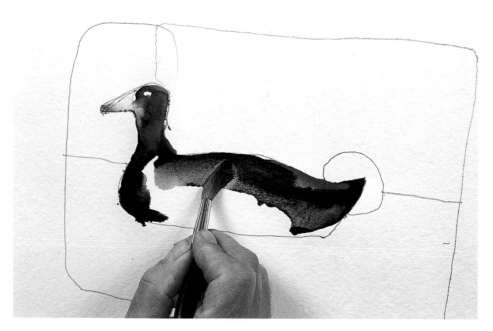

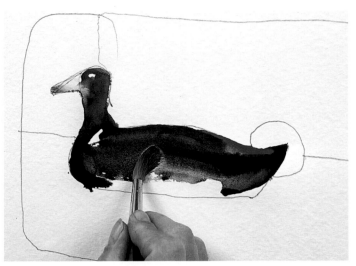

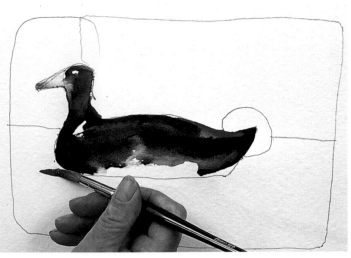

8: Working quickly, add some Burnt Umber or Burnt Sienna to your blue-black mix. (You'll probably need to recharge the whole mix from your color supply.) Paint with long zigzag strokes. Don't lift your brush until you run out of paint. Don't paint all of the way to the bottom of the bird (see step 9). Leave a white paper highlight toward the front of the body.

9: The paint from step 8 must still be wet to do this step successfully. Load your brush with Ultramarine Blue and place the tip about 1" (3cm) in front of the coot. Press the brush and start your stroke.

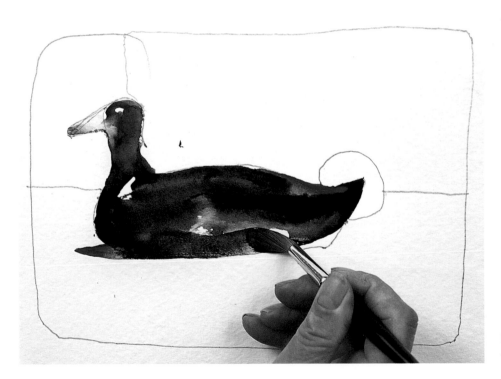

10: Paint along the base of the bird left to right. Since you are pressing down on the brush, the stroke is quite wide. Use Ultramarine Blue.

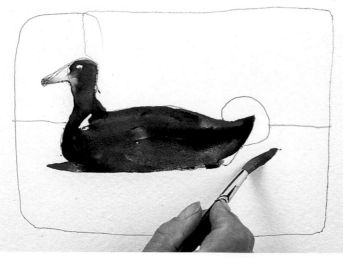

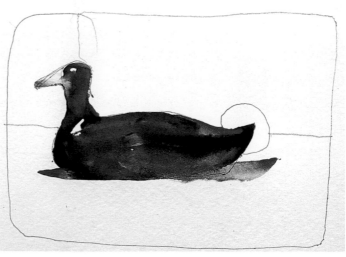

11: The paint from step 8 has blended with the paint from step 10. Don't assist in the blend; the paint must manage on its own. Now start a new stroke for the aft cast shadow with a loaded brush of Ultramarine Blue.

12: Paint from right to left under the bird and lift the brush using Ultramarine Blue.

13: Even though you started the cast shadow with quite a lot of paint, there should be enough water in the bird to lighten the stroke in step 12. Generally all areas will lighten more than you can imagine. Use Ultramarine Blue, Cadmium Yellow Light and Cerulean Blue.

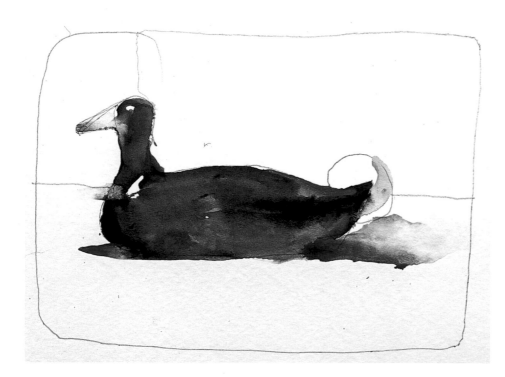

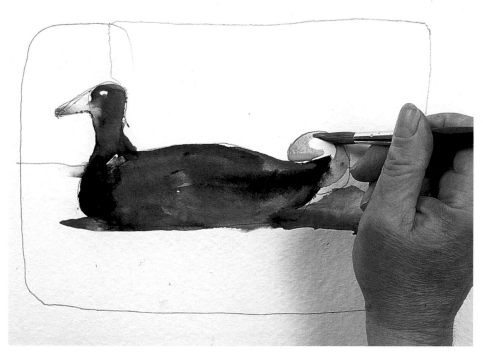

14: Load your brush with Ultramarine Blue and restate the cast shadow. The dark cast shadow gives the underside of the decoy from step 13 a suggestion of reflected light. Paint from left to right, out and up toward the apple. Notice that the lower edge of the wash is the darkest and hardest part of the wash. You want this closer edge to come forward. Remember: Harder edges and darker values want to come forward. The wash should lighten as it approaches the apple. Soften the tail a bit by painting the beginning of the apple with a curving yellow stroke down to meet the damp tail. Paint into the coot's chest with a damp brush to make a path out into the background. This keeps the coot from being isolated. Use Cerulean Blue and Cadmium Yellow Light.

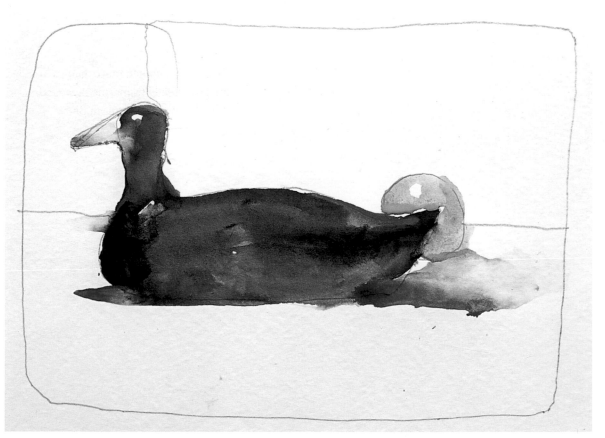

15: Leave a dry white paper separation above the coot's tail. Don't let the apple destroy this graceful shape. Take another look at step 14. Leave a strip of dry white paper between the cast shadow and the first apple stroke. As you finish the apple, paint down and over this white strip but hope for a suggestion of reflected light on the underside of the apple. The highlight is softened with a damp brush or the tip of a tissue.

Basic Principles of color mixing

Usually we look at something and try to figure out what color to use. Let's reverse the process. For this exercise, you'll need a very red apple and a ripe lemon, a round no. 8 brush that points well, watercolor paper (preferably 140-lb. [300gsm] cold-pressed) a board to place underneath the paper and these four colors: Alizarin Crimson or Carmine (Holbein), Cobalt Blue, Cadmium Yellow Pale and Yellow Ochre. In the materials chapter, I suggested using an easel, but if you're new to watercolor, working on a flat surface might be easiest for these beginning exercises. Always have your water, palette and paper as close to one another as possible. The table should be about waist level.

the basics principles of color mixing

- Do not overmix your paint. When you look at your palette's mixing area, you should see individual colors.
- Your palette's mixing area should have color swatches, not puddles of mud.
- Your palette's mixing area should never look watery.
- After rinsing and a shake, your brush goes directly to the color supply, makes a brief stop in the mixing area and goes directly to the paper, not back to the water.
- We're not aiming for a perfectly homogenized wash; you should be able to see the colors you are combining. You should have a sense of paint rather than water.
- Keep your palette clean. Clean it constantly so you won't be able to use that tired watery stuff in the mixing area.
- Clean your palette with paper towels rather than tissue. Many tissues have additives that leave an oily film that causes your paint to bead. New palettes should be cleaned lightly with paper towel and a cleanser to remove the oily film.

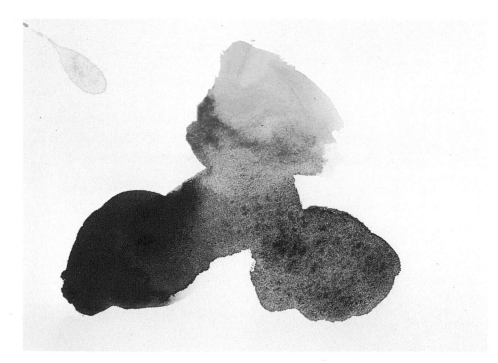

❀ Exercise 1
Allowing Colors to Mix on Their Own

Arrange the swatches of Alizarin Crimson, Cobalt Blue and Yellow Ochre in a triangle leaving a space in the middle. Make the swatches fairly wet but not watery. Rinse your brush and shake it with a flick of the wrist. Brush color from each swatch toward the intersection. Your brush should move color not mix it. Once the colors meet, lift your brush. You'll probably need to do several sets of swatches. It's okay to lift your board and jockey the colors a bit at first. Just don't use your brush for mixing. The colors might need as much as two minutes mixing time before they are dry. The purpose of this exercise is to show just how beautiful watercolor can be if you don't mess with it.

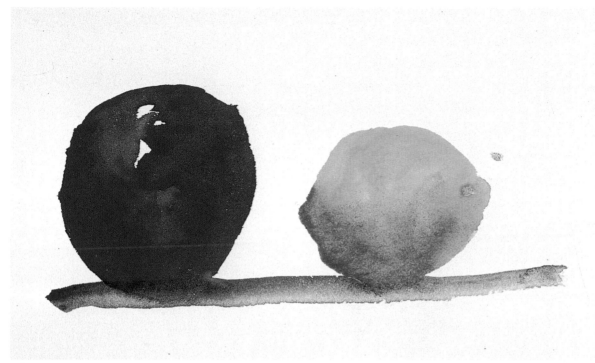

❀ Exercise 2
Develop Objects Using Pure Color

Let's turn these swatches into an apple and a lemon. Using Alizarin Crimson, make an apple shape. Then, with Yellow Ochre, begin the underside of the lemon, working toward the top. Before you get there, rinse the brush, shake it and do the top of the lemon with Cadmium Yellow Pale. Don't try to blend the colors. Starting at the left, run a stripe of Cobalt Blue under the apple, then continue on to the lemon; don't lift the brush until you've passed beyond the lemon. Put down the brush and watch what happens. The point is to learn about paint and water ratios and when to put the brush down and just watch.

tips

❧ Always start a stroke where you want the darkest value and hardest edge.

❧ When your brush tip is fully loaded, the tip and sides of your brush make a hard edge when the brush is pressed into the paper.

❧ The brush is usually held at about 45°.

❧ The brush handle points in the direction of the stroke.

❧ The brush is pushed into the paper, then stroked according to the shape of the subject, then lifted abruptly. (Don't feather.) It helps if you load just the tip.

❧ The edge will be softer and the value lighter where the body of the brush leaves the paper.

RULES FOR MIXING COLOR ON YOUR PALETTE

Rule 1
Rinse your brush and give it a shake. Your brush goes first to the color supply (Cadmium Red) and then deposits paint on the palette.

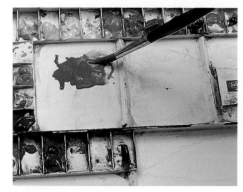

Rule 2
After another rinse and shake, your brush goes back to the color supply (Cadmium Green) and makes a brief stop in the mixing area. The red and green shouldn't be completely mixed.

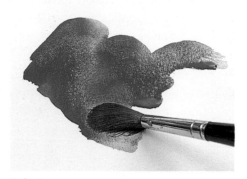

Rule 3
The brush goes directly to the paper, *not* back to the water for a rinse. You're not aiming for a perfectly homogenized wash; *you should be able to see the red and green.* You should have a sense of paint rather than water.

Rule 4
Do not overmix your paint. When you look at your palette's mixing area, you should see individual colors.

Rule 5
Do not make puddles of mud. Your palette's mixing area should have color swatches.

Rule 6
Do not allow your palette's mixing area to become watery.

seeing pure color as value

Sometimes people have trouble seeing certain colors as specific values, particularly the lighter and more intense colors such as red. I've asked students to look at a still life with a bright red flower and dark green surrounding leaves and identify the values they see. Very often they'll say "dark" for the leaves but "red" for the flower. When you're painting, it's important to identify each color you use as a specific value. Bright, strong colors often suggest a light value to people, while grayed, less intense colors may suggest a darker value. Don't confuse value and intensity. Remember each color has a specific hue, value, and intensity as it comes from the tube. Try to keep them separate in your mind.

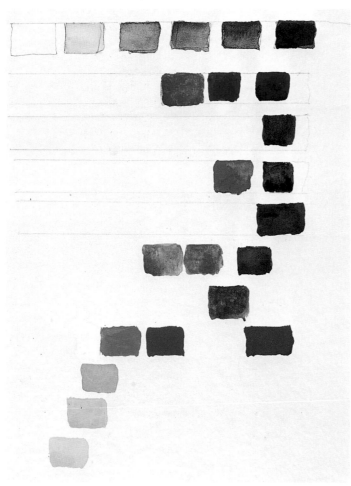

Pure Color as Value
To show you what I mean, I've painted a neutral value scale using Ivory Black for my darkest dark and then diluting my black with water until I get to a block of white paper for my lightest light. Under this scale I've matched the colors I use with one of the neutral values. This shouldn't be thought of as a precise matchup. You'll notice that some colors don't line up exactly. Sometimes a color seems to straddle two values. You'll see that I hedged my bets by lengthening some of my swatches.

create a value chart

On a piece of 140-lb. (300gsm) watercolor paper, draw two parallel lines about ¾" (2cm) apart. Below this, draw four or five more sets of lines. Then draw six evenly spaced rectangular blocks within your top set of lines. Number your blocks, starting with number 6 and ending with number 1. (Darker values in painting are always lower numbers; lighter values are always higher numbers.)

Mix moist Ivory Black on your palette with only enough water to make it fluid. Fill in number 1 with the Ivory Black. Don't rinse but dip the very tip of the brush (it'll still have the black used in block 1) into your water and paint number 2. You want a slightly lighter value. Continue the same process until you get to block 5. Getting a good even gradation is hard; I still have trouble with it. When the blocks are dry you may need slightly darker overwashes in some of them; just make sure the block is completely dry before adding its overwash.

Make sure your palette is set up in an orderly fashion with fresh or thoroughly moistened paint. You don't have to use the colors on my chart, but the palette should be arranged in color families with a value range within each color family. Have another small piece of watercolor paper on hand. Now you'll place blocks of the different colors on your palette in rows under or straddling a corresponding value in our scale. Making the neutral scale is a bother and you'll probably make mistakes. Place the edge of the second (practice) piece of watercolor paper under the scale on your master copy, and paint a block of color on the practice paper. Move the practice paper back and forth until you think you have a match. It's a good idea to let the block almost dry before deciding on a match. (If you're using the practice paper, your blocks on the master will have to be dry.) If you're using enough paint, your colors should hold their value as they dry. If you're using too much water or if your paint isn't moist, your colors will dry lighter. Work your way through the colors on your palette and place them in the same manner you see in my chart. Again, don't agonize. I've painted for years and found myself puzzling with my color-value matchups.

painting local color-value

Local color is a confusing term. You may think it's about a small section of color in an object. Just the opposite is true. Local color has as much to do with value as it does with color, and it refers to the intrinsic, overall *color and value* of an object independent of the effects of any light that falls on the object.

Let's assume there is an arrangement of fruit on a table and there's light shining on the fruit. Many students will try to paint the color and value they see on the light parts of the fruit. This is dangerous. A strong light that makes values look lighter can also suggest less-intense or washed-out color in the light sections of fruit and flowers. You must be aware of the effect of light and compensate for it. Never paint for the color value you see in the light; instead, paint the color value you see in the *halftones*. The halftone is the value where shadow and light meet. You'll be constantly amazed as what appears to be a strong color value fades as it dries. Always paint your colors in the mid-to-light value range richer than they appear. You'll never learn to paint if you continue to be timid with color and value.

Look at exercise 3 and observe that each object has an overall color-value. Work for a two-value difference between light and shadow at this stage. No rule always applies since painting is full of contradictions, so consider the "two-value light and shade difference" simply a handy reference. Notice that the darkest part of a round object's shadow ranges somewhere in the middle of the shadow. The purpose of the three examples is to train you to see local color-value and compensate for the lightening of water washes as they dry. You should try these exercises yourself.

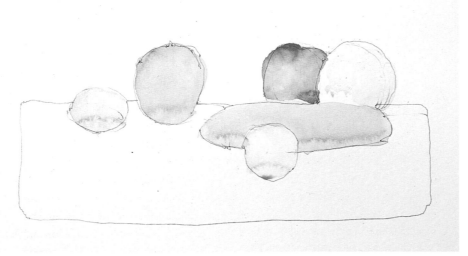

❀ Exercise 1
Weak Local Color

I've exaggerated a washed-out selection of vegetables on my table. I've painted a lime, apple, tomato, cucumber, lemon and white onion. I often see first washes like this in class. Usually the problem is dried-out paint and too much water. Sometimes it's fear of paint. Work small in your sketchbook. Flimsy paper is fine, just be ready to make lots of attempts. The better the paper, the more fear you'll have.

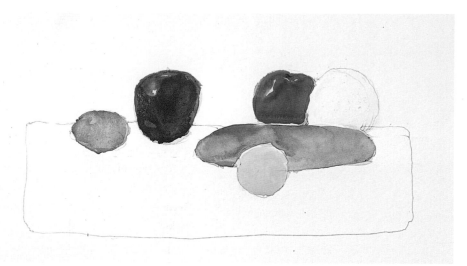

✿ Exercise 2
Strong Local Color

You should start this exercise with the fruit in flat light with no noticeable light and shadow.

Paint the fruit almost as flat shapes and then allow the paint to dry. Don't rush to add the shadows and darker values; you'll add those in exercise 3. You want your local color-value to be dry to the touch. Don't be too mechanical here. Let some accidental watercolor things happen, but concentrate on the true color-value of each piece of fruit and try to achieve this true color-value with the first try. If you can manage this, you're on your way!

Study each piece of fruit. Compare their relative colors and values: the lemon to the cucumber, the cucumber to the tomato and white onion. Remember that value cannot be seen unless it's compared with something else. Leave a skinny rim of dry white paper between some of the adjacent fruit to keep them from mixing with one another.

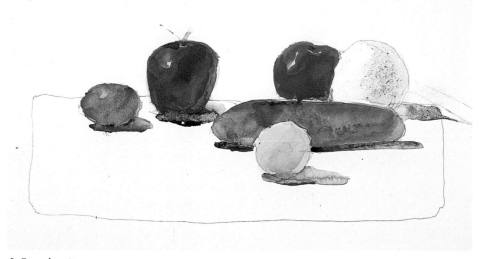

✿ Exercise 3
Adding Light and Shade

The second part of your assignment should be easy if the paint in the first part is totally dry and you have good local color-value. If you've done well with part one, you won't see dramatic differences when you add your darks in part two. A simple rule: Intense local color and dark local valued objects will not be as affected by a strong light as less-intense local color and lighter local valued objects. Mull this over a bit and make sure you understand the concept. It would be helpful to find a book on Edouard Manet. Manet's work is based on local color-value. My own painting and the ideas in this section rely on Manet's ideas.

Most of us have trouble with greens. I prefer to mix blues and yellows to create my greens but use premixed greens as a backup. I like the variety of color/temperature when I mix my blues with a cool yellow (Cadmium Yellow Pale), a warmer yellow (Cadmium Yellow Light) and then a warmer one still (Cadmium Yellow). If you want a really warm green, substitute Yellow Ochre or Raw Sienna. I choose my blue based on its value. If I want a lighter green, I choose Cerulean Blue (my lightest valued blue). I like Cerulean Blue with the Cadmium Yellows but wouldn't use it with Yellow Ochre or Raw Sienna (too opaque). The darker the blue, the darker the green. Cobalt Blue makes a mid to dark green. I use Ultramarine Blue for my darkest green. Ivory Black with a yellow or Raw Sienna can also make a dark green.

Adding a complement will gray or lessen the intensity of a color in light-valued color mixes. You're using water to control the value. In darker mixes, where you use less water, adding a complement will lessen the intensity, but more importantly, it'll darken the value of the mix. Many students add complements in their mixing areas and make homogenized and deadly darks that usually kill any possibility of luminosity in their shadows. Don't use any complements in your mid and darker areas; use only colors from the same color family. In the light-valued lemon, I do use an "almost" complement, but I'm diluting it with a bit of water to control the value.

In my cast shadows I usually use Ultramarine Blue or Cobalt Blue, but you don't want all cool cast shadows so try Raw Umber for warmer cast shadows as I did under the lemon. Color from the object should move into the cast shadow. The connection between a cast shadow and the object should always be painted wet-in-wet and blurred. The outside boundary of a cast shadow should be hard, especially near the object. Boundaries away from the object can blur slightly.

MIXING DARKS AND LIGHTS

Here are a series of paintings of a distant mountain range illustrating the darkening and lightening of the colors I usually use. These are only suggestions of hue mixes. You should experiment with other colors. Try to let your colors mix on the paper.

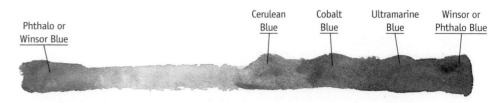

Intensify With Hues
Blues and reds are the only colors you can lighten or darken using just blues and reds, as they come from the tube at different intensities and values. All you need are the hues I've suggested and water. This is a good start if you're a beginner.

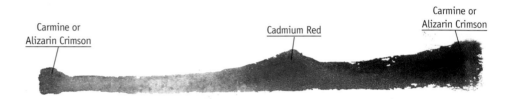

Use Water to Alter Intensity
Notice the intensity difference in the hues as water is added.

Don't Micromanage
Don't mistreat your colors with micromanagement. Wet colors should be placed next to one another and then allowed to mix themselves.

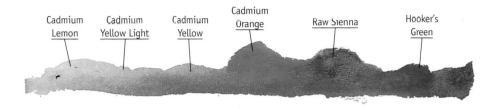

Cadmium Lemon · Cadmium Yellow Light · Cadmium Yellow · Cadmium Orange · Raw Sienna · Hooker's Green

Use Similar Colors to Change Intensity

As you continue to look at my mountain ranges, you'll see I lighten with colors that are related: red to orange to yellow.

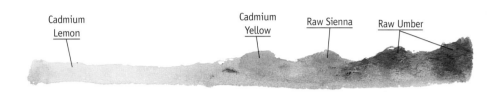

Cadmium Lemon · Cadmium Yellow · Raw Sienna · Raw Umber

Don't Let Yellow Become Too Dark

Yellow is the hardest color to darken. Raw Sienna and Yellow Ochre work, but they're opaque and can make dull shadows.

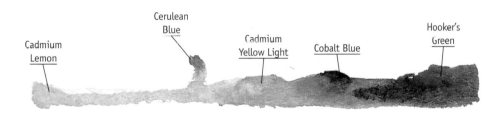

Cadmium Lemon · Cerulean Blue · Cadmium Yellow Light · Cobalt Blue · Hooker's Green

Use Blue to Darken Yellow

To achieve a good dark yellow, you'll need to go to a blue. I like Cerulean Blue. It's a gentle blue and comes from the tube at a middle value. You can also mix Hooker's Green with Cadmium Yellow Light.

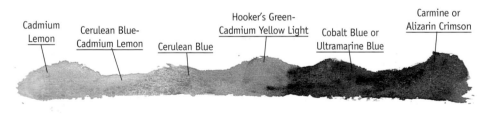

Cadmium Lemon · Cerulean Blue–Cadmium Lemon · Cerulean Blue · Hooker's Green–Cadmium Yellow Light · Cobalt Blue or Ultramarine Blue · Carmine or Alizarin Crimson

Alter Intensity With a Related Color

You'll usually lighten with a different but related color that comes from the tube at a lighter value.

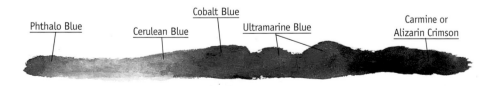

Phthalo Blue · Cerulean Blue · Cobalt Blue · Ultramarine Blue · Carmine or Alizarin Crimson

Don't Lighten With Water

Don't rely on water to lighten. Your color will be washed out. Exception: You can use water to lighten dye colors such as Carmine, Alizarin, Phthalo Blue, Mineral or Winsor Violet.

MIXING COLORFUL GRAYS

There are two kinds of grays: bad grays and good grays. Bad grays happen when people overwork and use tired puddle color from the mixing areas of their palettes.

Good grays are made with complementary colors, are mixed freshly each time from the color supply and aren't overmixed. I mix my colors, as much as possible, on the paper. Let the complements mix on their own with as little interference as possible.

I've made five color swatches. You don't need to worry about the color wheel, just remember that the complement of red is green, the complement of blue is orange, and the complement of yellow is purple or violet. These color swatches will teach you two things. The first is that a combination of pure color against a more neutral color suggests a richness that wouldn't be possible with a combination of colors of equal intensity. The second lesson is that partially mixed colors, mixed on the paper, are more interesting than thoroughly mixed colors from the palette's mixing area.

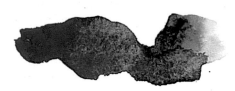

Cadmium Red Light and Green
I usually use Cadmium Red with green to create gray. Alizarin and Carmine are more transparent than other reds. (Alizarin or Carmine mixed with green is fine; it tends to make a darker gray).

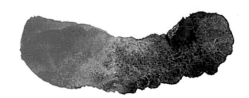

Cadmium Orange and Blue
Swatches like these look lovely in themselves. It's the pure color seen next to the partially blended color (you won't see this if you overmix).

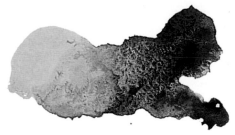

Cadmium Yellow, Blue and Carmine or Alizarin Crimson
I've used the generic blue, red and yellow. Experiment with the various blues and yellows and substitute them to make your own swatches.

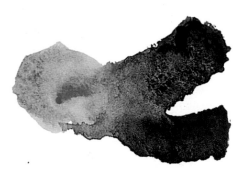

Raw Sienna or Yellow Ochre, Blue and Carmine or Alizarin Crimson
I've always used Raw Sienna or Yellow Ochre as a substitute yellow. They are opaque but I'm wedded to them.

Burnt Sienna, Burnt Umber and Blue
Burnt Sienna and Burnt Umber mixed with blue makes a rich dark gray. Don't use Cerulean Blue; it's too opaque and light in value.

seeing negative and positive shapes

Positive shapes are the objects you're painting. Negative shapes are the background and objects behind the thing you're painting. Many students only consider the objects they're painting and think of the background as a separate issue to be dealt with later. This is dangerous. Oddly enough, the background is often more difficult to paint than the objects in your still life. Backgrounds are an integral part of a composition and should be given as much attention as the things you're painting. If you do a good job on your still life and haven't done anything with the background, you'll become traumatized with fear of ruining your still life with a tentative background.

Negative shapes are most important when you have a light-valued flower and need a darker shape or background to give the light flower substance and shape.

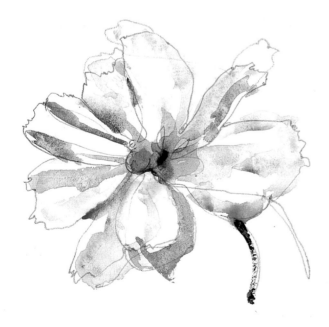

Too Much Detail
This is what happens when you're consumed with the texture and detail in the white flower and ignore the background. The more you study the flower, the more details you'll see and want to paint.

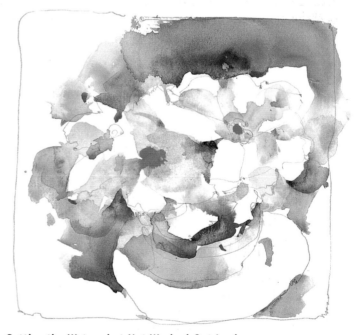

Getting the Watery but Not Washed-Out Look
In this painting of a bunch of peonies, I've allowed more interchange between the flowers and the background. I've left the sketch in a rather rough and unfinished state. Most students want to overdefine every flower and leaf. In the assignment above, I spoke of "the essence of flowers." If you overdefine and explain every petal, you will lose the sense of softness and mystery. Your flowers will look rigid and brittle if you overdefine.

MIXING SIMPLE SHAPES ON PAPER

Set out your complete palette in an orderly fashion. You'll need a block or a sheet (and board) of 140-lb. (300gsm) cold-pressed paper, your palette and a no. 8 round brush.

You will be limiting yourself to one color for each flower, then adding a stem. You will not use glazes or overwashes. Any value change will be done wet-in-wet in the first wash. Each flower shape will be painted on the first try with no corrective brush work. You will make a series of the same flower shape for this demonstration, experimenting with slight variations in your water-color ratio. You must capture the essence of a flower with value changes and hard and soft edges with your first strokes.

colors
Alizarin Crimson • Cobalt Blue
Mineral Violet • Yellow Ochre

1. Paint the basic shapes. Mix up a rich swatch of Mineral Violet on your palette, rinse and shake your brush, place the tip at the base of the flower, press the brush to the paper and make your upward strokes, lifting abruptly at the end of each stroke. You must have more paint than water to manage this.

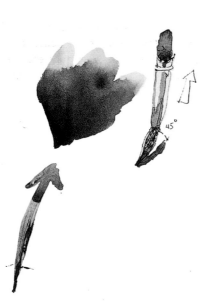
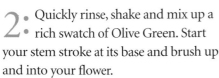

2. Quickly rinse, shake and mix up a rich swatch of Olive Green. Start your stem stroke at its base and brush up and into your flower.

3. Lay your brush down and see what happens. The green and the violet should merge.

MIXING DETAILED SHAPES ON PAPER

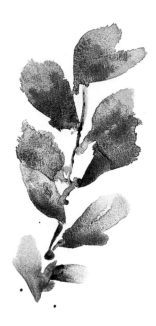

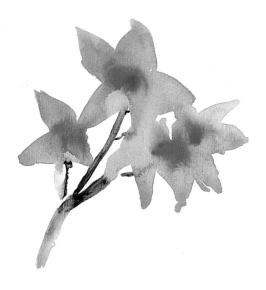

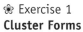 Exercise 1
Cluster Forms

Now try the same brushstrokes as used for mixing simple shapes but make smaller individual shapes, letting some overlap and run together on their own. You just place the paint. The color, water and paper do the mixing. You'll see that some of my blooms didn't come out beautifully. Learn to live with mistakes. Add the Olive Green stems. Use your no. 8 brush for the stems as well as for the blooms.

Exercise 2
Yellow Radiating Forms—Daffodils

Your no. 8 brush point starts at the petal's tips, presses and strokes toward the center. I'm using Cadmium Yellow for the flower, Cadmium Orange for the centers and Olive Green for the stems. Make a series of radiating forms. Several should overlap but there should be islands of white paper within the cluster. Rinse your brush, shake it and dip it into your Cadmium Orange. Place a spot of orange into the center of each flower while the flower is still wet. Add the stems using Olive Green.

CONTROLLING EDGES

Edge control is the ability to know where and when to leave edges firm, or "found," and other edges soft, or "lost," without conscious thought. You should not think about the boundaries of the things you're painting. Instead, you should think of the boundaries of lights and darks. This is one of the hardest ideas in painting. Most students want to paint the boundaries of things. Paint light and shadow shapes first, then paint the object.

Think of three steps as you're painting: (1) Make your shape; (2) correct the shape for value and color (wet-in-wet); and (3) soften edges where necessary. These three steps should become completely natural, done without thinking.

Technically, everything you paint should have lost and found edges. The idea is that you can emphasize or stress some boundaries with a found boundary while minimizing other areas with a lost boundary. Lost boundaries help you connect adjacent objects and shapes, avoiding the cut-out-and-pasted-down look of a painting done entirely with found edges. You can decide which boundaries will be hard and which will be soft by squinting and comparing values. If a boundary appears hard with an apparent value contrast between adjacent shapes when you squint, the edge should be hard. If adjacent values seem to merge with a less apparent separation while squinting, the edge should probably be soft.

Generally edges out in the light will be harder than edges in shadow. Harder edges will tend to come forward while softer edges will tend to recede. Harder edges with value contrast attract the eye, while softer edges with less value contrast tend not to catch the eye.

You must have a good water-to-paint ratio to soften edges properly. If you have too much water, you'll lose the dark to light transition.

For these exercises, I'm using Ivory Black and water since I don't want you to worry about color, and a no. 8 or no. 10 round sable brush.

In almost all cases, paint toward the still-wet shape you are softening with a rinsed damp brush. Basically your making a damp path that allows the shape to escape. Remember to keep the brush on the paper.

❀ Exercise
Softening Using a Zigzag Stroke

Make your shadow or dark shape and quickly rinse and shake your brush. Start your softening stroke about 1" to 2" (3cm to 5cm) away from the shape. Keeping the brush on the paper, make a series of zigzag strokes. Don't paint too far into the shape to be softened. Remember that you're just making a damp escape route, allowing the paint and water to do the actual softening.

tips

- Don't attempt to soften a dried edge. This usually causes "mushy" overworked edges.

- Cast shadow edges are normally hard with the most value contrast where the cast shadow meets the light. Cast shadow and shadow edges are soft and lost where they meet.

- Paint the light and dark separations not the object separations.

- Remember to squint. And keep comparing one section of your subject with another section. If you concentrate in one section, the edges will invariably appear hard. The value contrasts between adjoining sections will appear stronger than they should.

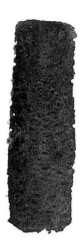

1: Start with a strip of slightly diluted Ivory Black.

2: Rinse and shake your brush with two hard shakes. Place the midsection of the brush on the upper or lower edge to be softened

Draw the cleaned damp brush down or up with one continuing stroke. The tip will be out in light area. The midsection of the brush is on the edge to be lightened. The key is to press the brush lightly but firmly. You mustn't lift or change pressure on the brush during the stroke.

3: Clean and shake the brush and run the brush up or down the light edge. You are actually using the side of your round brush and making the same stroke you'd make with a flat brush.

small areas

Make a single stroke into the spot to be softened. Stop the stroke and lift. Do this when you want a very subtle softening. Try this, but it's easier if you swivel the brush and backtrack before lifting the brush.

assignment one

Follow the guidelines I've suggested. Make a block. Soften its edge. Continue making blocks and softening an edge in each. Don't stop to correct. Some will be better than others. Vary the amount of paint in the dark block and the amount of water you use to soften. Don't paint too far into the dark block, but try to note what happens when you do. Be conscious of when you seem to be using too much water or not enough.

Most important: Keep your brush on the paper until you've completed a passage. You can lift and rinse again if you need to lighten or "feather" the lightest boundary of the softening stroke.

assignment two

Sometimes you'll want to soften several parts of a shape but keep other parts hard. Make a rectangular shape. Paint into it in three places. As I mentioned earlier, you'll have to experiment, determining whether stopping and lifting or swiveling the brush and backtracking works best for you.

Learn Edge Control Painting
Wild Daffodils

A first sign of spring is batches of wild daffodils along a stone wall in an abandoned roadbed near our house. I've used some for this exercise.

colors

Cadmium Lemon • Cadmium Orange
Cadmium Red • Cadmium Yellow
Cadmium Yellow Light • Carmine
Cerulean Blue • Cobalt Blue
Deep Sap Green • Olive Green
Raw Sienna • Yellow Ochre

brushes

Nos. 8 and 10 round sables

color mixing

Color mixing on the paper is nice but hard to keep a consistent value. It's more important to keep a consistent value and have good edges. If you're getting color blotches, do more of your mixing directly on the palette.

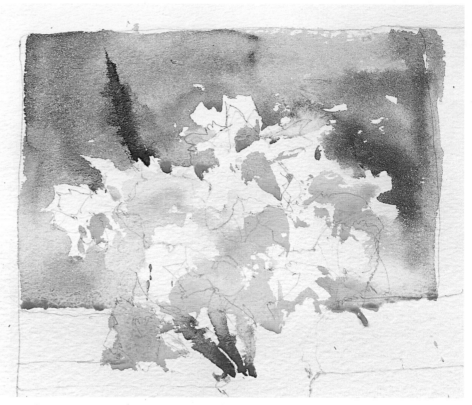

1: Create a contour drawing. Because there are very light-valued flowers, start with the background, painting around the blossoms. Don't isolate your lighter shape with a solid surrounding dark. It's best to vary the background with strokes both parallel and perpendicular. This will let your light shape breathe and give you both hard and defined edges as well as slightly softer edges out in the light. Don't pre-wet your paper. Mix your green, yellow and Raw Sienna on the paper, wet-in-wet. Leave white paper for hard edges in the flowers, but let some of your yellows meet the still-wet background to make some blurs. You want to start right off with a watery look with both lost and found edges.

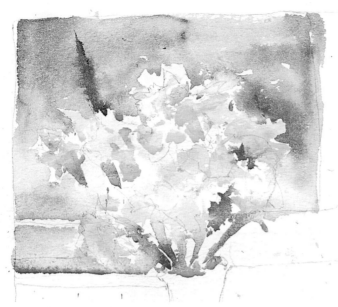

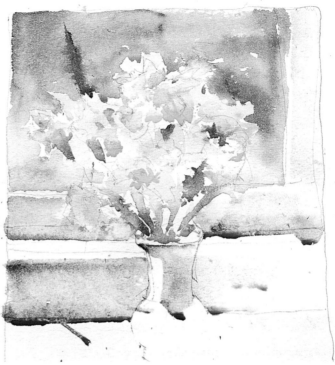

2: Add a window frame. Create the hard edge along the top of the sill and in the edge of the cast shadow. Add more yellows and stems. Work pretty quickly here to make sure you can get blurs where the stems meet the flowers. Let the paint and water do the painting. Paint a yellow flower on the left and let it mix with the window frame.

3: The left boundary of the vase where it meets the lower window frame should be firm since it faces the light. The shadow on the vase is also hard at this point. Mix your blue, Yellow Ochre and Carmine on the paper. You should still see the partially mixed color. Paint across the shadow boundary of the vase into the window frame on the left.

4: Squint and paint separations where the light meets the dark. Don't paint separations at object boundaries. Here's a close-up of the lower part of the vase. Study where the kept edges stay separate and where they cross over. Paint the light, not the object.

5: Finish your cast shadow. You'll see color changes where Cobalt Blue, Yellow Ochre and Carmine meet the cast shadows. Try to get the shape of the cast shadow with consistent values.

6: The scissors are painted with Cadmium Orange, Cadmium Red and Raw Sienna. Use Cobalt Blue for the cast shadows. Paint the scissors handle and the Cobalt Blue cast shadows so that the colors can merge. The cast shadows have a firm edge.

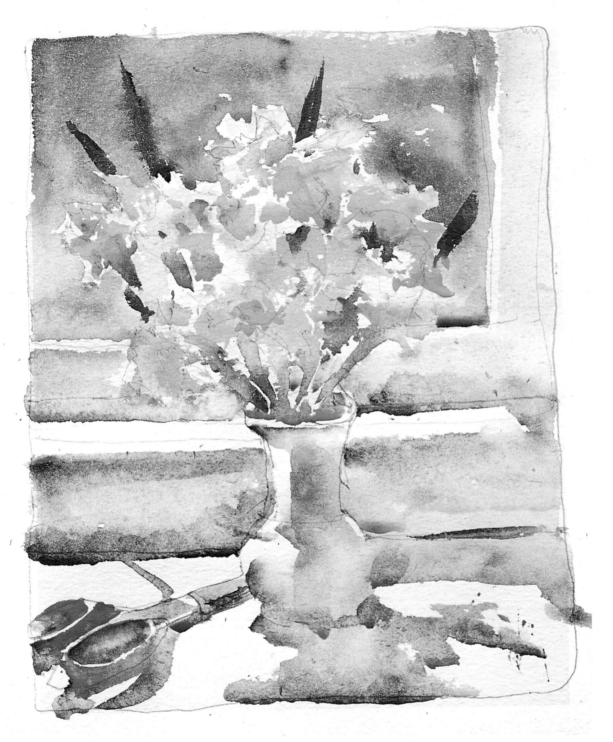

7. A painting is finished when you find yourself refining and adding small darks. Add a firm edge in the vase's shadow where it meets the light. The body of the vase isn't round but is made up of a series of obtuse angles. Don't fuss too much; let it end gracefully.

creating compositions

No one ever complained about the composition in a good painting. Someone with nothing better to do devised rules of composition. If we followed these rules, our paintings would always be safe, correct and boring. Norman Rockwell and Pierre Bonnard have two things in common: First they were both good painters and second, both broke the conventional rules of composition. Bonnard and Rockwell never developed a center of interest, both artists put important elements at the lower boundary and corners of their pictures and both artists designed their paintings with the placement of flat shapes of color and value.

general principles of composition

- **Color**. You can't compose a picture with a pencil sketch. Object placement isn't important. It's where you place your colors and values that count, so you need to compose with a color-value sketch.
- **Boundaries**. You must be aware of the placement and size of your objects in relation to the size and shape of your paper.
- **Backgrounds**. Backgrounds and surroundings are always harder to compose than the objects in your painting. Never start drawing and painting without asking, What will I do with the background? Too often we do a good job with our subjects and then choke with fear. The added backgrounds are bound to be tentative and probably not as good as the subject.
- **Shapes of color and value**. All painting is based on the abstract idea of arranging shapes of color and value in relation to one another. You've decided the relationship of your objects in relation to the picture's boundaries and you've made sure all of the objects are the correct size in relation to one another, but the placement of color and value shapes is much more important than the placement of objects.

Possible Problems

I've combined several problems in my drawing (forgive me for exaggerating):

- The objects are lost in space.
- The boundaries were ignored.
- The subjects do not interact with the background.
- The objects are disproportionate.
- The artist has emphasized the objects he favors (flowers) and shrunk the objects he does not care for.
- The artist is being too frugal; he needs a lot more stuff to fill the space.
- The composition is too symmetrical.

My Solution

Make a crowded picture, with as little background as possible. Close-up and dominant objects are more interesting than middistant little objects. In my compositions, I like to:

- Connect my objects to at least three picture borders.
- Balance dark values on one side of a picture with intense color on the other side of the picture.
- Put strong colors at the borders of a painting.
- Always avoid having a center of interest; the whole painting should be interesting and in focus.
- Juxtapose warm and cool colors throughout the picture.
- Make a haphazard and accidental arrangement of things into a seemingly well-composed painting.

exercise in composition

Set up a simple still life. Use a white table-cloth, flowers, red and green apples and a white vase and pottery. A couple of your pots should be white or light in value. Make three drawings, about 7" x 6" (18cm x 15cm). Unfortunately I used a black ballpoint and didn't realize the ink was water-soluble so it messed up my yellows. I suggest a waterproof pen for this exercise. I'd like to wean you from correcting your pencil drawings. If you use a pen, you'll concentrate. I'm using nos. 4 and 6 round sable brushes. Have a spotlight handy but don't turn it on until example 3.

I said in the beginning of this section that there shouldn't be rules in composition. Even the faults I've mentioned could probably work in the right hands. Like everything else in your painting, composition should reflect your ideas.

| Example 1 | **Squint and Paint**

Squint and paint each object, concentrating on local color-value (the inherent value and color of an object). Paint each color and value as if it were a flat shape.

| Example 2 | **Change Color and Value**

Don't change the positions of your objects but pretend that some of the objects have switched their colors and values. Change a dark object into a white object. Change a red apple into a yellow apple. You can keep some objects their actual colors.

| Example 3 | **Create Shadows**

Revert to the actual colors and values of your still life (example 1). Turn on your spotlight. You should see definite cast shadows on your white tablecloth and definite shadows on your white and light-valued objects. Squint at your red apples and other darker objects. Notice that light and shade is a bit harder to see. Darker, more richly colored objects should retain their local color-value out in the light.

The colors and values in the shadows and cast shadows are *real* in painting and just as important as the colors and values in the objects.

I hope you'll see that you have three completely different compositions without moving a single object.

contour drawing

Contour drawing prepares you for watercolor in two ways: It provides articulate shapes necessary for painting and moves you into the right, or abstract, side of your brain. Most students want three things: (1) accuracy, (2) to draw and paint "things" and (3) to be in total control.

Watercolor for me is an accidental medium painted with control that is rooted in and based on abstraction. In painting, abstraction is a withdrawal from worldly objects into a world of shapes. Contouring helps you see that the things you're drawing aren't things but rather shapes that intertwine and connect. Think of contouring as if you were a weaver of shapes rather than a drawer of things.

1: First establish your picture boundary. Never start in the middle of a page and think you'll solve the outlying areas later. Start your flowers, working both inside and outside. Try for some simple larger shapes along with more complicated smaller shapes.

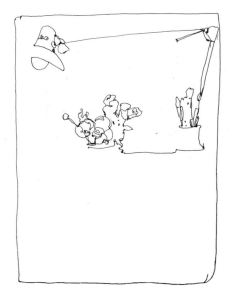

2: Complete the flowers. Normally you won't lift your pen, but occasionally you'll want to show an opening or "see-through" where you can lift and show these negative shapes. Draw the flowers starting at the top of the jar. Keep the pen on the paper, and stop at the jar's right-hand boundary. Then plan your trip, with the head of the lamp being your destination.

Your pen goes across and through the brush jar, up to the brushes and continues on through the arm of the lamp to the lamp's head and bulb. Stop here and connect the bulb with the lamp using one continuous line.

basics of contour drawing

There are some basic rules in contouring that will be hard to follow at first.

- Much of the time you'll be drawing very, very slowly.

- When you look up at the subject, your pen or pencil stops but stays anchored to the paper.

- You must stop every time you come to a direction change.

- You'll determine the angle and the distance to travel until the next direction change.

- When you stop and see a curve ahead, you'll check where you have to get to, then speed up to make a smooth and graceful curve.

- Don't think you must finish one part before going on to a second part.

- A contour is not an outline of a subject. You must draw the inside and outside simultaneously to capture its contour. Practice your contour drawing skills using this step-by-step demonstration of my drawing board.

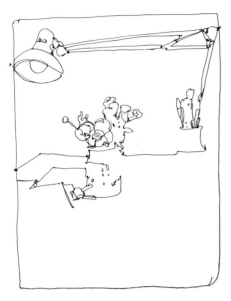
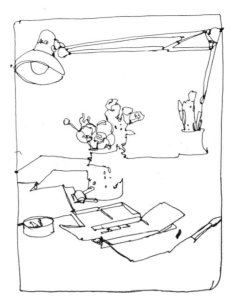
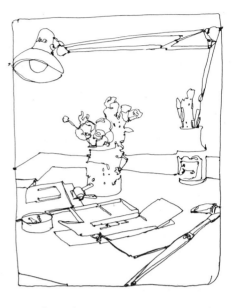

3: Notice the small *X* and dots where the lamp connects with the picture boundary. When your pen intersects with a picture boundary, you can lift the pen and take a breather. Find a new starting point—the left lip of the flower jar. Finish the tabletop and connect to the picture boundary. Finish the arms of the lamp. This is a connection with the upper right picture border so go back to the flower jar, add some small forms and start out into the adjacent piece of paper, book, clip and bottom of the flower jar.

4: Concentrate on shapes and angles rather than trying to draw the palette. Compare each angle and distance to travel with angles and shapes you've already drawn. As you draw the upper line of the palette, very slowly, look up at the flower jar. The lower right corner of the jar tells you to stop and start down at about a 95° angle for the right side of the palette. You'll see that there are many boundaries "open" instead of enclosing each shape. It's similar to a maze. You will find closed paths but you should be able to travel from one section to another about 80 percent of the time.

5: The palette meets the brush, which connects the drawing to the lower picture border. You've found your way out of the maze.

a road map

Think of contouring as if you were making a trip and looking at a road map. Look at the object you want to draw and see the possible paths you could take. You could take the quick way around, or you could take the scenic route. Contour drawing takes you the scenic route. Enjoy your trip.

overworking

My teacher Frank Reilly said that beginnings were more important than finishes. I think many people are thinking of their paintings as products. There's no use to them if the paintings aren't finished. I wish you could forget about finishing and instead think of each painting as a part of the process of learning what happens when paint and water work together. When I have student self-critiques in my classes, I always hear, "It's overworked." It's easy to see that a painting is overworked when seeing it from a distance. It's hard to realize you're overworking when you're painting.

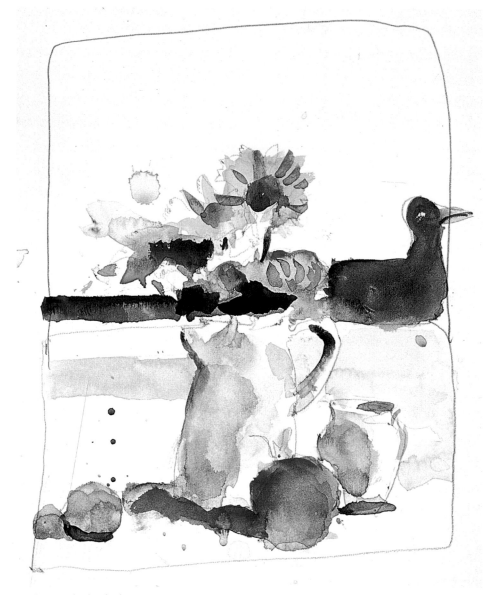

An Overworked Painting
I tried to do everything wrong:

- I blended my colors thoroughly into puddles on the mixing areas of my palette.
- I restated all of my darks as separate sections. I wanted to get the darks right, even if it took me two or three times.
- I saw a lot of value and color changes in the apples and tried to match exactly what I saw.
- I painted over light and midvalues when they were still damp.
- I painted my object's shadow, let it dry, then came back later and added a cast shadow.
- Getting accurate shadow shapes on the vase and mustard pot seemed a nuisance, so I just "indicated" them.

❀ Exercise
Prevent Overworking

You need to set a time limit—about half an hour. You want to work quickly to keep the paintings fresh. Next, set up a very simple still life; anything will do. Do not make it into a production. Make a square, lightly penciled boundary on a small watercolor block. Avoid Arches blocks: They require too much effort. Keep it small, 8" x 10" (20cm x 25cm) or 10" x 12" (25cm x 30cm). Always adjust your paper space to your subject and what you want to paint. Never feel like you must fill an awkward rectangle if it doesn't suit your picture idea.

Paint your still life ten times, each within your allotted time. Put each picture away. They are finished. *Don't* come back in the evening and try to touch them up. Let them sit and then judge. I gave myself a bit more time for this painting than the one on the previous page, and added some subjects. This is a better painting but I still didn't go back into the painting to correct my mistakes.

Only you can decide the limits of your paintings. When you don't know what else to add, you'll only subtract if you add another stroke.

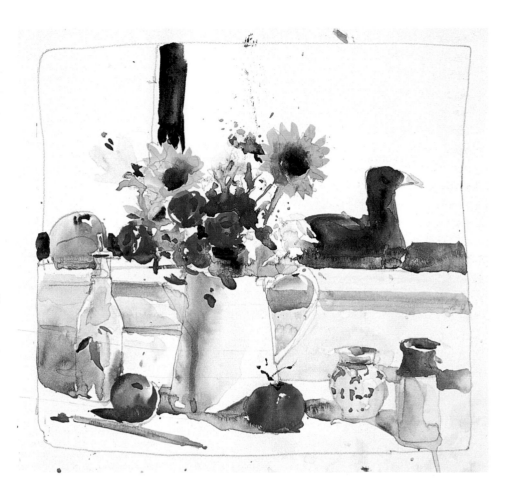

<div style="text-align:center">

why paintings are overworked

</div>

▨ **Weak color and watery washes.** You can't go back with darks later. If a painting doesn't have good local color-value in the beginning, adding darks later usually makes for a "spotty," fragmented and overworked picture.

▨ **Fear of colors being too strong.** You'll learn more about painting using too much color.

▨ **Overmixed colors.** Use color from the paint supply, not from the mixing area.

▨ **Overprinting with darks.** If a painting is high in key and looks weak, live with it.

▨ **Wrongly timed overwashes.** All light and mid-value washes must be very wet or totally dry before adding an overwash.

▨ **Too much time.** The less you know about watercolor, the less time you should paint on a picture. If you have two hours, do two paintings. Don't spend one hour for painting and one for fussing and correcting.

▨ **Painting too fast.** Paint deliberately, consider each stroke and make each stroke important.

▨ **Too focused on detail.** Painting is about illusion. A painting can't copy nature. You can't paint what you see. The details you see in a light flower can destroy the essence of a light flower. Are the details in the flower more important than the essence of the flower?

▨ **Painting objects not shapes.** Paint adjacent objects of equal value. Squint and paint adjoining parts that have similar value at the same time.

▨ **Repainting.** Repainting a section will isolate it and make it foreign.

▨ **Restating a dark.** If you must restate a dark, look at the part of the dark that's next to a light. Always repaint a small area of a dark. Never repaint the whole dark with another layer.

▨ **Fear of failure.** I'm supposed to be really good at painting. If I can fail, you can fail.

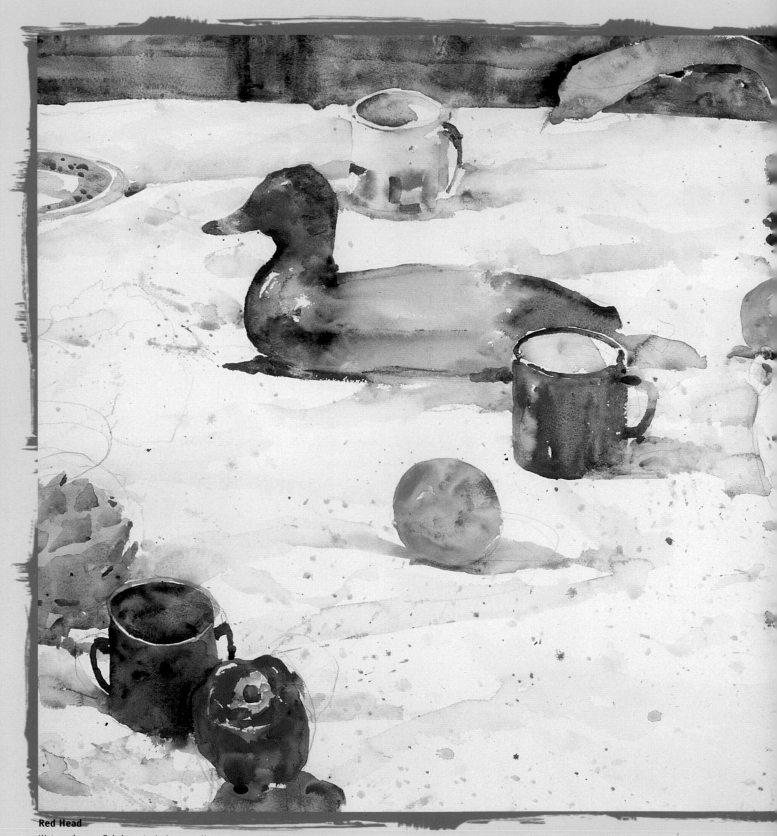

Red Head
Watercolor on Fabriano Artistico 140-lb.
 (300gsm) Paper
22" x 30" (56cm x 76cm)
Courtesy of the Munson Gallery

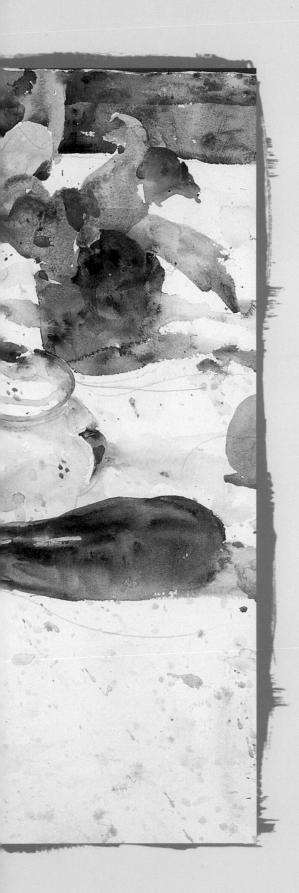

Painting Fruit, Vegetables, Leaves and Flowers

DO NOT WORRY TOO MUCH ABOUT COLOR AS YOU PRACTICE THE exercises in this section. You want simple value contrasts between leaves, flowers and background. Try not to be subtle; be obvious. Don't make lots of value variations within individual leaf and flower forms. Remember to always think of local color-value. Local color-value is the inherent value of an object in flat or diffused lighting.

Changing the color of paint often alters values. When you add a pure complement to a color, the tonal value of that color will automatically darken. This can cause some discordant and spotty value changes where you don't want them. With practice, you'll be able to judge how much water to add to your complement so you can keep subtle color and value changes that don't look spotty. This is complicated and confusing if you're new to painting. Follow my mini demonstrations. If your efforts look confused and spotty, it's probably because you are not ready to make color changes within single forms and still hold the local value.

Before starting, glance through the mini demonstrations in this section. Notice that I keep similar local values with only minor value changes within individual flower and leaf forms. I do add color changes but that's only icing on the cake. First you must understand that a good painting is made up of simple, uncomplicated local value shapes.

Good paint consistency is very important in getting results on your first effort. The paint on your palette must be wet. When you mix paint and water, it should be fluid and filled with color, not watery and indolent.

This section is separated into different vegetable, fruit, flower and leaf forms: complicated and simple, describing the physical identity of individual flower and leaf forms. If you examine anything closely, it will become complicated. Instead of examining, squint and find simplicity.

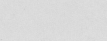

washed-out color

Fruits provide wonderful "spots of color." Set up your still life. Remember that an intense lighter color is equal in importance to a dark-valued dull color (check Creating Compositions, pages 44-45). It's amazing how little color mixing is needed in painting fruit. That's why it's a good place to begin. Most students use too many colors and overmix in the mixing areas of their palettes. Another common problem is the use of too much water or too little paint. Please review the sections Seeing Pure Color as Value (page 29), Basic Principles of Color Mixing (pages 26-28), and Painting Local Color Value (pages 30-31) if you have any questions.

Remember: Local color-value refers to the inherent color and value of an object regardless of the light that might be shining on the object. Ignoring local color-value will often lead to washed-out and vapid paintings. Students often blame the blandness of a painting on weak values. Often the problem is weak and washed-out local color-value. Don't ignore weak color in the light areas by trying to correct with darker values in shadow. Adding darker values in shadow often makes for heavy, dead and murky shadows. This is especially true when the dark is added over a dry shadow. Darks are best added when the shadow is still wet.

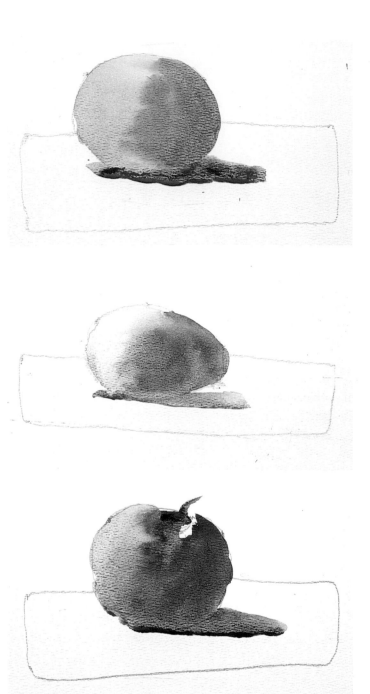

Lost Local Color-Value
I've painted an orange, avocado and tomato. The local color-value has been lost and the light side of each fruit lacks substance. The shadows are fine. They're simple without confusing value changes and mix nicely with the cast shadows, but envision a painting made up of the fruit I've painted—objects with strong shadows lacking any strength out in the light. The painting would be spotty, made up of bits of small strong darks.

WASHED-OUT LIGHTS

Students often stress the darks and seem drawn to the shadow side of any object. This interests me as a teacher. Most students want to know what color I use but often paint bland colors and concentrate on dark values in shadow hoping to give the painting punch. This usually leads to overworked spotty paintings.

Weak first washes are common. I often hear, "Oh, that's just my first wash. I'll come and correct it later." Why not try for a good colorful first wash? The fewer the layers, the fresher the painting. Overwashing or glazing is a traditional approach to watercolor painting. The problem is that the artist must be very experienced and allow plenty of time for each wash to dry perfectly before an overwash is added. Many of us aren't experts and won't have perfect conditions when working outside a studio. If a light or mid-valued wash is not completely dry, your overwash tends to remove the under wash and make muddy and overworked paintings.

Watery Wash
Here's a good example of a weak and watery first wash.

Added Shadow
Once dry, a shadow is added to the first wash. The artist forgets to soften the edge and will have to come back later to soften it.

A Bad Wash
Two things could have happened to this unfortunate apple: The artist may have tried to soften the shadow with a watery brush, or a second watery wash was added when the first watery wash was still damp.

painting a tomato

Let's give the poor apple a rest. You'll need a ripe, very red tomato for this exercise.

Remember: The shadow and the cast shadow shapes must always be thought of as a single shape and painted at the same time. Painting the shadow and cast shadow at the same time accomplishes four things. (1) A cast shadow anchors your subject to its surface; (2) you paint two shapes as one, saving a step; (3) when you paint warm shadows wet-in-wet with a cool cast shadow, you have both warm and cool color connections and color vibration, and color from the object seeps into the cast shadow suggesting reflected color; and (4) painting your shadow and then continuing into the cast shadow forms an escape for the water that otherwise will puddle and make a watermark in the lower part of the shadow.

colors

Cadmium Orange • Cadmium Red
Carmine

1. Start in the upper left, press your brush to the paper and paint down. Use mostly Cadmium Red with a bit of Cadmium Orange. This forms the left, light-side boundary. Leave dry white paper for highlights.

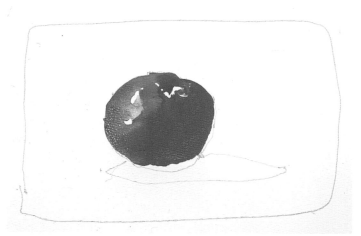

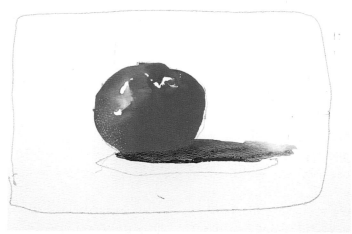

2. Immediately reload the brush with Carmine and Cadmium Red from your wet paint color supply. Your brush should only be wet enough to keep the paint fluid. After reloading, complete the tomato without lifting your brush from the paper. Use the lower midsection of the brush. Soften the highlight with the damp, not wet, tip of the brush. The highlight area should still be damp.

3. Paint one continuous stroke under the wet tomato and out to the right forming the cast shadow. Soften the boundary at the end of the stroke with a clean damp brush.

painting an avocado

In this exercise, you will use an avocado, but a cucumber or lime would work just as well.

I'm not using complements in the tomato or the avocado. Don't worry about what color to use in cast shadows. I tend toward cool cast shadows since I like blue, but you need warm ones as well. I've used a warm cast shadow in the avocado in this example.

colors

Cadmium Yellow • Cobalt Blue
Raw Sienna • Raw Umber
Ultramarine Blue

1. Start your color in the light area. The brush work is the same as in the tomato. Use very moist Cadmium Yellow and Cobalt Blue painting around the highlight. Use more yellow in the lighter sections and more blue in the darker sections. Mix the yellow and blue on the paper.

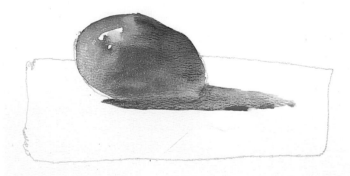

2. Mix about 80 percent Cobalt Blue and 20 percent Cadmium Yellow on the paper. Keep your dark green rich and dark enough so you won't have to do an overwash. Keep your brush on the paper. Load your brush, go directly to the color supply and mix your darks on the paper (never work out your mix on the palette). Work from upper left to right, moving from light into shadow, painting down toward the table. You need only enough water in your brush to keep the paint fluid, but avoid any suggestion of drybrush. If you need to go darker, you can switch to Ultramarine Blue.

3. Add Raw Sienna and Raw Umber for the cast shadow, working from left to right while the avocado is still wet. If you finished the avocado along its lower border, your brush is running out of paint strength. You'll have a subtle lightening and a suggestion of reflected light when you add the cast shadow.

COMBINING VEGETABLES

You'll paint a jalapeno pepper, a clove of garlic, an orange and a tomato. Never try to paint a white object against a totally white background. You'll clutter the light part of the object with minor detail in an effort to show form. You'll need a darker background or a dark object to explain the white shape in the light area.

colors

Cadmium Orange • Cadmium Red
Cadmium Yellow • Carmine
Cerulean Blue • Cobalt Blue
Olive Green • Raw Sienna
Ultramarine Blue • Yellow Ochre

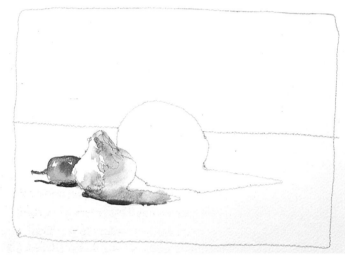

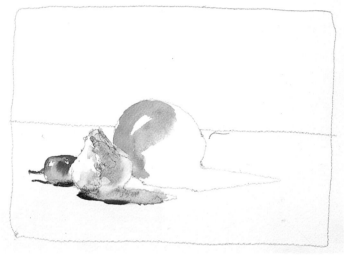

1. Starting at the top on the left side of the pepper, use Cerulean Blue and Cadmium Yellow to paint down around the highlight to the bottom. Without lifting the bush, paint over to the underside of the garlic. Your brush's paint is losing value as you work down. Carefully describe the garlic's boundary with Olive Green. You want a nice crisp edge around the garlic, so paint back, right to left, through the center of the pepper. Add a Cobalt or Ultramarine Blue cast shadow along the lighter, underside of the pepper. The light side of the garlic is finished. Now paint a shadow shape in the garlic. Always start your shadow where it meets the light. Use Cerulean Blue with a touch of Yellow Ochre. As you paint toward the orange, your values are lightening. Use Ultramarine Blue on the left and then some Raw Sienna for your cast shadow. Color and some water may seep into the cast shadow. Do not correct it.

2. Make some soupy Cadmium Orange to begin the orange. Start your stroke at the almost-dry garlic. Some yellow may seep into the garlic, which is okay. The garlic mustn't be too damp or you'll get too much bleed. Paint a single stroke up and around the highlight.

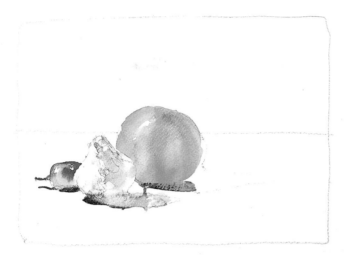

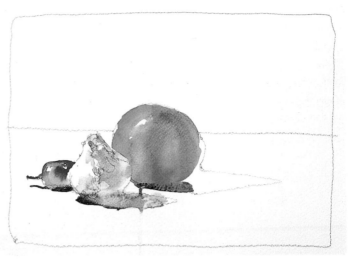

3: Quickly add a little Raw Sienna to the Cadmium Orange and finish the orange. Again the darkest part of the orange's shadow is near the light. Add a Raw Sienna–Raw Umber cast shadow immediately.

4: A drip of Cadmium Orange arrives in the garlic's cast shadow. A happy accident adds some warmth. Add Cobalt Blue and continue the cast shadow to the right toward the tomato.

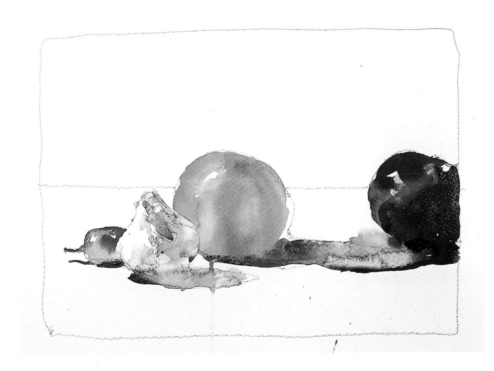

5: Try to let things happen and avoid correcting. This is very important. Try to let the watercolor "do its thing" even if you use too much water. Some color seeps into the Ultramarine Blue cast shadow. This adds reflected color to the cast shadow. Colors that mix on their own are usually better. Don't try to maintain complete control. The tomato is painted with Carmine, Cadmium Red and a bit of Cobalt Blue. Combine these colors on the paper and add a bit of Olive Green in the stem. The tomato and the orange are basically flat shapes with highlights to give them form.

A Carton of Strawberries

Whenever you have a grouping of single flowers, fruits, vegetables or leaves of the same color and value, you'll paint them as a single shape. Then you'll find subtle divisions, finding individual pieces without isolating them. The hardest part is to find some separation without overworking. You'll want to keep separating and defining. If you overdefine individual parts, you'll lose simplicity.

colors

Cadmium Orange • Cadmium Red
Carmine • Cobalt Blue • Olive Green
Ultramarine Blue

1: Check for light parts of the strawberries and basket and leave islands of dry white paper. This approach can be used for any box of berries or cherry tomatoes. Be careful to avoid painting over these lights. Think of the massed berries as a color swatch, working wet-in-wet. Don't add shadows, just keep good local color, using plenty of fluid Cadmium Red, Carmine and Cadmium Orange. Don't mix all of these colors together on your palette. Study my example. Look for the places where I add and mix the different colors on my paper.

2: Compare this step with step 1. The strawberries are now completely dry. Lightly add minor overwashes with Cadmium Red and Carmine, making sure not to disturb what's been painted before. Do not soften any edges. Be careful with complements. When you add full-valued Cobalt, Ultramarine Blue to a red or Carmine, you'll have a very dark value. You want luminosity and light in your shadows so it's best to avoid complements in your shadows until you're sure you need a really dark dark. Use Carmine only to show shadow separations in the strawberries. The shadows aren't really dark; they contrast just enough to suggest form and definition without getting deep and heavy. Use Olive Green in the stems. Show the basket without being rigid by letting some strawberry color pass over some of the basket dividers.

A BUNCH OF CARROTS

This drawing isn't as considered as it should be. When you suffer artist's block and don't know what to paint, try spending a morning doing contour drawings of a bunch of carrots. The irregular shapes will force you into your right brain. If you can draw an irregular bunch of carrots really well, you can draw most anything. The painting part is easy. Can you cross over boundaries? Instead of painting each individual strawberry, leaf or carrot, can you begin by painting the whole bunch first and then come back to find the individual strawberries, leaves and carrots? This is the most important lesson in this demonstration.

colors

Cadmium Orange • Cadmium Red
Cadmium Yellow • Cobalt Blue

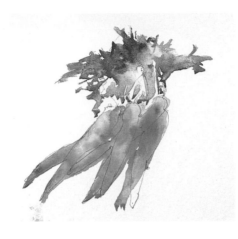

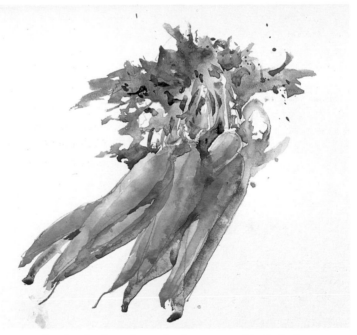

tips

- Always stress local color-value when painting strong colors and dark values. Don't worry about light and shade.
- Always start painting strong colors and dark values at the spot nearest the light source.
- A highlight can suggest form without light and shade.
- Always start a shadow shape at a spot nearest the light source painting from the light, never toward the light.
- Always make a shape, check the shape for color and value, add more color or value if necessary and soften some edges.
- Remember to squint. If there is contrast between adjacent values, keep a hard edge. If it's hard to find a separation between adjacent values when squinting, soften the boundary and lose the hard edge.
- Try to make all decisions while the paint is still wet.
- Never paint for a value or color in the light areas. Always paint for a color or value seen in the halftone.

1: Paint the carrots with Cadmium Yellow and Cadmium Orange mixed on the paper. The leaf stems are Cobalt Blue and Cadmium Yellow with dry white paper left for the lighter stems. Think of all of the carrots as one shape with minor color and value changes. The leaves have more value changes but still should be thought of as one shape.

2: Paint the shadow shapes in the carrot with Cadmium Orange and Cadmium Red. Avoid blue in the carrot's shadows; it makes the shadows too dark. Paint the shadow shapes in the leaves with Cobalt Blue and Cadmium Yellow. Your mix should contain less water and be a bit bluer and a bit less yellow than in step 1. The cast shadows have harder edges and are darker values where they meet the light. Allow the Cadmium Orange from the carrot to bleed into the Cobalt Blue of the cast shadows.

mustard jar and fruit

I've painted a favorite mustard jar and added a green apple and tomato. This is a great exercise for those who have trouble finding time to paint. You can find almost all of painting's essentials in these three simple objects: painting lost and found edges, using good rich color, and connecting adjacent objects.

I use a very limited palette, repeating different proportions of the same colors throughout the picture. I also let colors from one object bleed into adjacent objects to get color tie-ins. I used Da Vinci maestro round sable brushes nos. 6, 8 and 10.

colors

Cadmium Red • Cadmium Yellow Light
Cadmium Yellow Pale • Carmine
Cerulean Blue • Cobalt Blue
Raw Sienna

1. There's a fairly strong light coming from the left. Don't try to paint a white object in a flat light; it'll have no form. Start with Raw Sienna and add a bit of Cobalt Blue to set off the closer edge of the jar's opening. Make the closer part of the shadow darkest; you want the far edge of the jar to recede so that's where you want a lighter value. Use Raw Sienna and Cobalt Blue to paint a darker background around the right side of the jar's opening. You can't show the light part of the jar without a darker background.

2. Start the shadow wash where it meets the light side of the jar. Paint the background around to the left to bring the light side of the jar into focus. You have a hard definite edge here.

Be careful your wash doesn't get too wet on the jar.

3. You want to isolate the light side of the jar but still soften the edge between the light and shadow on the vase. This will also be the darkest and coolest part of the jar. Use Cerulean Blue and Carmine. The strong blue makes the beginning of the cast shadow on the jar and the cast shadow under the jar. More important than color is the moving from one area to another with the color, connecting all the areas of similar value without consideration of the area identity.

4. Finish the apple, leaving some white highlights. The apple blends with the darker cast shadow in the jar.

The white part of the jar is an effect, where you have the darkest dark and lightest light. The dark pattern on the jar is painted over dry white paper and continues into the wet shadow where it loses strength, lightens and is absorbed into the jar's shadow. You want most value contrast out in the light. You want your shadow to have as little value change as possible. Shadows should have color changes rather than value changes.

5. Always start your strong color in the light areas. Use the Cadmium Red directly from the color supply to paint the tomato. Do not worry about light and shade in fruit and vegetables when painting an intense color like the one found in this tomato. Colors always dry lighter and less intense than you paint them.

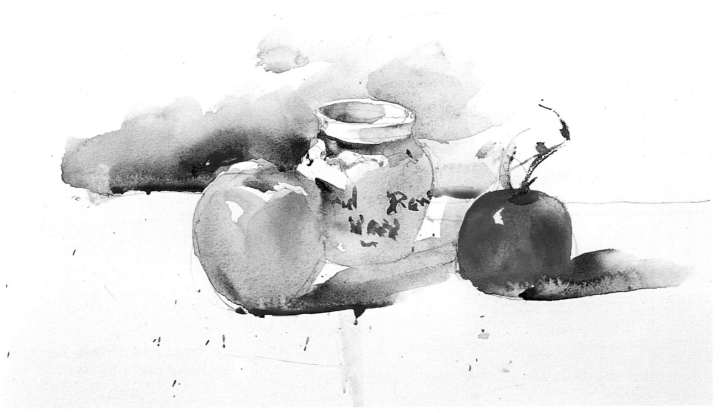

6: Finish the tomato with Cadmium Red and Carmine. The Cobalt Blue cast shadow meets and bleeds with the tomato. Let the water do the work. Don't correct. Let the watery cast shadow sit while you paint other things. It's best not to become obsessed by troublesome areas. Paint a section of background to focus the light right rim of the jar and tabletop. Be careful of detail in shadow. Make the lettering a midvalue or lighter. You can absorb puddles of color with almost-dry darker paint. Add Cobalt Blue under the tomato. Lift out excess moisture in other places with the tip of a tissue.

A WINE BOTTLE WITH FRUIT

Darks are a wonderful time to use rich colors right from the tube. Look at the reds, blues, greens, Ivory Black and earth colors on your palette. You want a dark for this bottle. Your palette will tell you the colors to choose. Don't worry about the relative transparency of the colors. You'll be working directly without significant overwashes.

You'll need fluid dark color, which means lots of water and even more paint. You'll leave some dry paper highlights, making careful shapes.

Don't think of the bottle as a symmetrical shape with a pencil outline to be filled in with solid dark. Study the finished painting. I've lightened one side of the bottle, allowing the bottle to connect with the white background. Here's the problem: You want to keep the background white. If you paint the bottle as dark as it looks, it will look cut out and pasted down. The only solution is to lighten the dark, usually on the shadow side. Remember you normally stress the darks facing the light source. That's where you want the viewer to look, (see the section on creating effects, page 66). Use rich and dark fluid color. Try to paint your bottle on the first try.

colors

Cadmium Orange • Cadmium Yellow
Cadmium Yellow Light
Carmine • Cobalt Blue
Ultramarine Blue

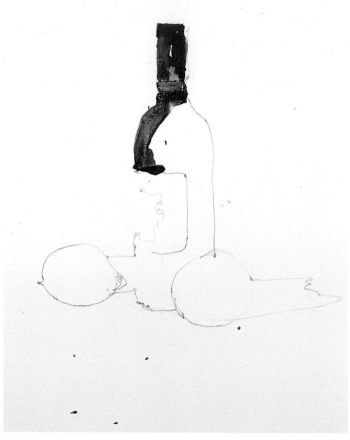

1: Primary colors and all dark colors should keep their local color-value when exposed to a strong light (local color-value is the inherent color and value of an object before it's exposed to a strong light). Paint the red with as strong a red as possible out in the light, leave a small highlight of dry paper and add Carmine for your shadow side, wet-in-wet.

Paint a band of green around the neck. Then paint down the light side of the bottle with Cobalt and Ultramarine Blue. Always begin painting a dark or shadow where it should be strongest. The red and green are still wet so they will work into the blue. Paint down to the label, leaving a hard edge.

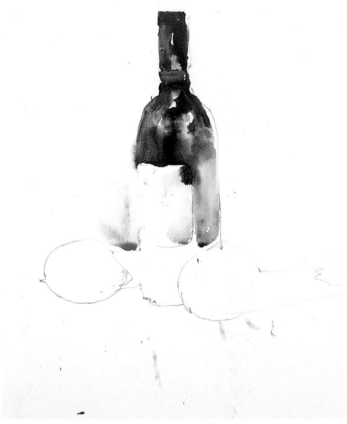

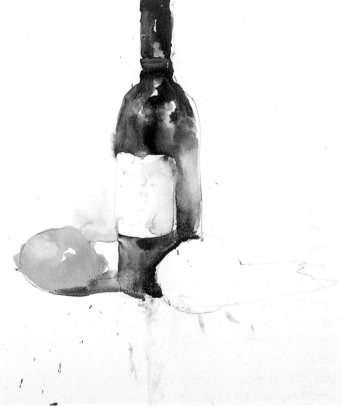

2: Use Ultramarine Blue, Cobalt Blue and Carmine for the bottle. You can use almost any dark color, but paint the bottle wet-in-wet. Leave some dry paper as highlights. Do not keep the hard edge on the label as you move into shadow. Clean your brush, shake and paint a damp path with some diluted Carmine and Cadmium Yellow Light from the label out into the bottle. Remove any blotches like the one in the label with a tip of a tissue. Using the same Carmine-yellow mix, paint a light background to contrast along the left side of the label, which should be dry.

3: You want a firm edge on the underside of the label. Some of the yellow and Carmine from step 3 has come down into the lower part of the bottle. Wait for the label to dry a bit. Don't rush an area that needs drying. The lemon needs to be painted. I often ignore light and shade in lemons; instead, go to the Cadmium Yellow Light in your paint supply, dig in with your brush and paint the light side of the lemon with your rich Cadmium Yellow Light. Leave a dry bit of highlight and finish the shadow side of the lemon with Cadmium Yellow. Immediately add a dark Ultramarine or Cobalt Blue cast shadow. Starting at the base of the lemon, paint right to the bottle.

The lower edge of the label should be dry by now. Paint your cast shadow up into the bottle. Paint the bottle below the label using Cobalt Blue and Carmine, allowing it to blend with the color painted up from the cast shadow. Let whatever dark color you use mix by itself.

creating effects

Effects are places of emphasis where you have the hardest edges and the most value contrast. Never make everything equal in your paintings. Some parts should be colorful; other parts quiet. Some parts should have definite and precise edges, while other parts should be lost and blurred. Effects are not centers of interest. A center of interest or focal point suggests a single part of a painting that's most important. Effects should happen throughout your painting.

Creating an effect is your way of telling the viewer where to look. Normally you want the viewer to look at your light areas rather than your shadows. This is why you use less value contrast and lost edges in shadows. You make the viewer look at your light areas by using your hardest edges and most value contrast. Here's the hard part: Keep your strong value contrasts out in the light. This means you'll have to keep your darks facing the light source dark. And lighten the darks in shadow where you want less contrast. This defies reason and what your eyes are telling you. You can't paint what you see. That's why you have to squint. You have to alter what you see for the sake of the picture.

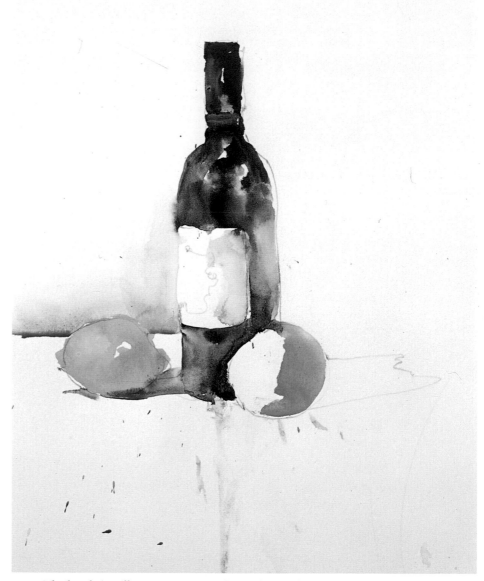

4: The bottle is still wet. You want a clean edge on the orange so you'll have to wait. Paint Cadmium Orange on the dry left side of the orange. Add a bit of Cobalt Blue to make a firmer edge in the background.

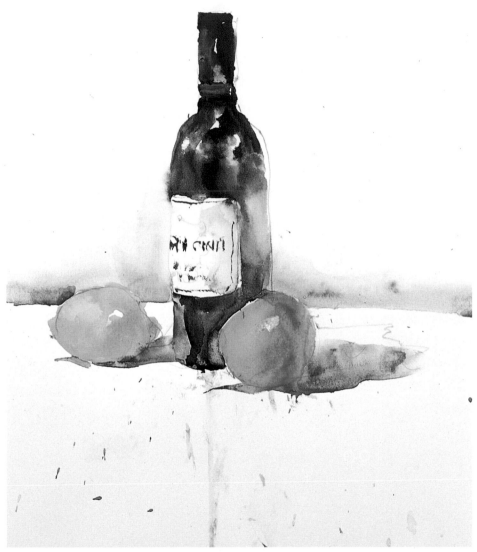

5: Now you will finish the orange. The bottle is still wet so the only thing to do is
• leave a slight rim of dry white paper so the bottle won't bleed into the orange.
Again do not try for value contrast in the fruit. Paint the light side of the orange with
Cadmium Yellow, leaving a dry white highlight.

slender leaf forms

You will need moist fluid paint and nos. 8 and 10 sable brushes that have full body and sharp points (the wider and longer the leaf, the bigger the brush). Color isn't as important as controlling your brush. In exercise 1 you'll make a series of simple long strokes using Hooker's and Olive Green. The strokes in exercise 2 are more involved with variations of leaf shapes. You will still use Hooker's and Olive Green but will add Oxide of Chromium Green (a good musty green) and Cadmium Yellow Light to lighten the leaves. Exercise 3 shows how to give a long slender leaf form and substance. For the lower parts of the leaves, you will use Cadmium Yellow Light. You could also try a mix of Carmine and Cadmium Orange with a moderate amount of water. Don't over-mix, keep your mixing area clean with paper towels and constantly mix new batches of light but vibrant color.

colors

Cadmium Orange • Cadmium Yellow
Cadmium Yellow Light • Carmine
Hooker's Green • Olive Green
Oxide of Chromium Green

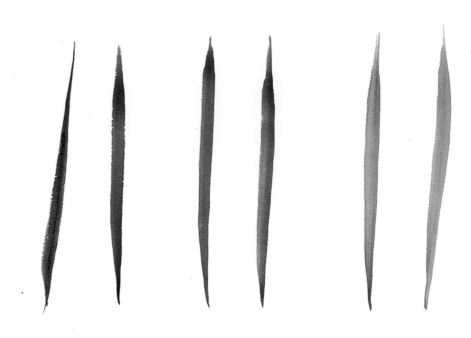

❀ Exercise 1
Slender Strokes

Use Hooker's Green for the four strokes on the left. The two examples on the right are painted with Olive Green. Hooker's Green makes a cold green and Olive Green makes a warm green. Make six leaf strokes about 10" (25cm) high. You'll start your stroke with your brush tip, then press down to the center of the brush's body to widen the leaf and make your stroke. Start releasing the pressure on your brush and end the stroke with the brush tip. Start at the bottom of the leaf, painting about halfway up and then start the stroke at the top of the leaf and paint down. Practice this exercise several times.

A B C D

✿ Exercise 2
Daffodil Leaves

The leaves are 10" (25cm) high. (a) Mix fluid but not watery Cadmium Yellow and paint up from the base for 3" to 4" (8cm to 10cm). Rinse and shake your brush and load it with Hooker's Green. Work quickly. Start your stroke with your brush tip, press down almost to the ferrule and stroke down to meet the yellow. Let the green and yellow mix on their own. If the mix doesn't work, try again with a new leaf. Don't correct or overpaint. (b) Use the same strokes. Switch to Oxide of Chromium for the green. (c) Vary the pressure on your brush, lifting and pressing. You want the widening and narrowing that you see in a daffodil leaf. (d) Start with yellow at the top and alternate with any green and yellow as you work down about halfway. Stop and paint from the base up with any green. Work up to meet your top stroke.

✿ Exercise 3
Two-Sided Slender Leaves

Read this exercise thoroughly before starting. You need to understand the sequence and have fluid wet paint at hand. Paint from the base as well as from the top of the leaf. Always remember to paint up as well as down. You can't paint wet-in-wet with just a downward stroke. Slender leaf forms often have a light side and a darker side. (a) Using any pure dark green, start with your brush tip, press slightly and make a thin 6" (15cm) stroke. The completed leaf will be about 10" (25cm) long. (b) Paint up with your diluted base of yellow, Carmine or orange for about 3" (8cm) until you meet your first stroke. Let them blend without help. Mix a darker version of your fluid green. Beginning at the top of the leaf, paint down and against your first green stroke. Don't lift the brush until you reach the base color. Lift your brush and stop. (c) Repeat step b using a different variation of colors.

A B C

Medium Leaf Forms

Follow the exercises in this project and make practice strokes. Don't make a preliminary drawing. At first, you'll be using a single value, but you should see some subtle value variations. Try to make each leaf with one stroke, keeping your brush on the paper from the beginning to the end of each leaf form. Don't "dab and peck" with your brush. You'll need a full-bodied no. 8 brush with a good point.

Mix a little Hooker's Green (dark or light) with a bit of water on your palette. Make sure to use plenty of pigment with just enough water to make the paint fluid but not watery. We will not be doing any overwashing. Try for the correct value the first time. You're in a middark to dark value range, so there should not be too much lightening as the paint dries.

colors

Cadmium Yellow Light • Hooker's Green
Olive Green • Raw Sienna

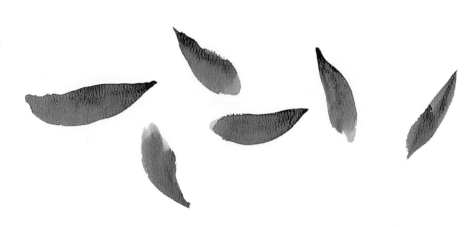

❀ Exercise 1
Medium Leaf Forms

This exercise is very simple. This series of strokes will give you an idea of the strokes you'll use to paint a leaf. Start with the point of the brush, then press the brush into the paper using a smooth continuous stroke with the hand and a fairly firm wrist. End the stroke. Try lifting the brush abruptly in some strokes. In others, continue the stroke with a follow-through into the air. Some leaf forms will be better than others. Don't worry or try to correct them. Just make another. Each stroke should look a bit different, with the paint and water actually finishing the effort.

removing puddles

If you're working on a slant and a puddle develops at the tip of the leaf, rinse and shake your brush. Then using the brush tip as a sponge, gently lift out some of the excess water. This causes less damage than dabbing with tissue.

❀ Exercise 2
Adding Details

You'll make two parallel strokes, beginning and ending the strokes with the tip of the brush. Start one side of the leaf with the brush tip, press and then release at the other end. Repeat the same stroke for the other half. Leave a white strip of paper to show the two strokes and to indicate the lighter division running down the center of many leaves. Don't get too excited by this little trick and become too involved with details. Concentrate on simplicity.

❀ Exercise 3
Warm and Cooler Leaf Forms

Use the same brush work to complete these leaves. Keep your brush on the paper. Use the wet paint in your color supply as your source, and the mixing area only as a stopover. It's a place to work out the paint and mix color just a bit. The upper warmer leaf is painted with Olive Green (a warm green) and Raw Sienna. The lower leaf is painted with Hooker's Green (a cool green) and Cadmium Yellow Light.

Broad Leaf Forms

Here you'll add some bleeding hearts to make the leaves a bit more interesting. The finished image should be about 6" x 8" (15cm x 20cm), so you'll need a fairly big brush. Use a no. 10 or no. 8 round sable with a good point. Concentrate on the overall shape of the leaves, using wet-in-wet, starting with midvalued greens then adding the darks. It is always better to add darks that will have soft edges as you're painting your first wash.

This is a difficult project. You need fluid paint, good outside shapes in the leaves and good flower shapes. You can't isolate the flowers so you'll need lost and found edges in the flowers. Start with the lower leaf, then you won't have to worry about the flowers. Color mixing always consumes people, so simply use Hooker's Green, Sap or Olive Green.

colors

Alizarin Crimson • Cadmium Yellow Light
Carmine • Cerulean Blue • Cobalt Blue
Hooker's Green • Olive Green • Sap Green
Ultramarine Blue

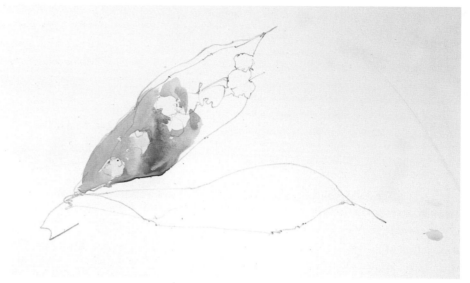

1. Start at the lower section of the leaf and paint up and around the flowers. Vary the value of the greens around the flowers so the flowers don't get isolated.

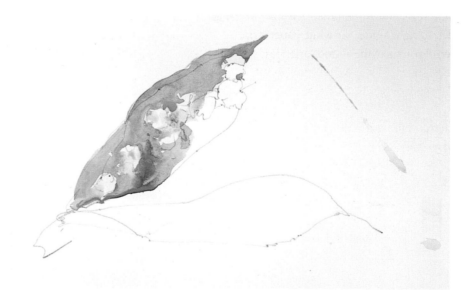

2. Mix a bit of Carmine, yellow and water on your palette. You want a light blush of color in parts of the flowers but it can't be watery, so give your brush a good shake before going to the flowers. Add the flower blush while the greens are still wet. You may have some runs. Try to live with them. Your flowers should have both distinct and fuzzy edges. Continue your leaf around the bleeding hearts. Try to keep some of the characteristic delicate shapes in the flowers. You must always place the brush tip (with green) at the light shape you want to describe and then paint out, continuing on with the leaf. Add some darker blue-yellow mix to accent the lightest shape of the flowers. If some water has worked its way down the lower leaf lobe, let it do what it wishes.

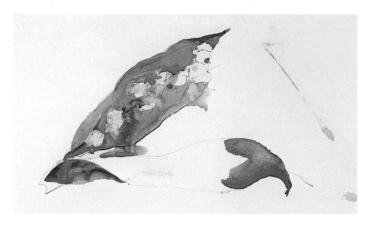

3: The top leaf is dry now. Leave a dry paper separation to keep a firm edge on the lower section of the first leaf. Work at an angle so paint and water will gather at the rim of the dry paint. To keep the lower section dark, take a tip of tissue and absorb some of the water or add some dark green or blue, wet-in-wet. The upper part of the leaf is lighter and curves over to make a shadow. When the upper leaf is completely dry, paint a cast shadow under the lip and around the bleeding hearts. This will be your only overwash. Check its value and correct it wet-in-wet. Start your lower leaf from both ends since you want a dark base and dark leaf tip. Remember, you get the darkest value at the beginning of the stroke.

Make a color accent with Cerulean Blue under the top leaf.

4: The dark section on the left of the lower leaf is dry. Paint the green mix from the right tip of this leaf over the top of the lower leaf until you get to the narrow section of the leaf. Then lift and load your brush with a midvalue mix of blue and yellow. Paint back to connect the top half of the leaf.

Leaving a strip of dry paper, go back and repeat the same stroke, painting from left to right, under the white paper strip, until you meet the almost-dried leaf section shown in step 3. Use your no. 10 brush with lots of fluid paint. Quickly mix more Ultramarine Blue and some yellow and run the brush along the lower edge of the bottom leaf.

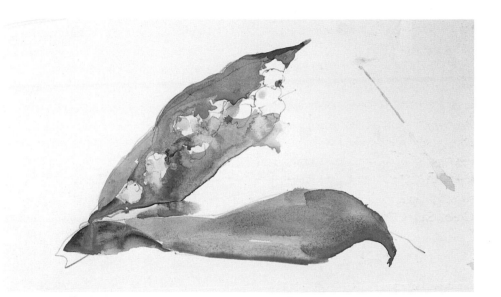

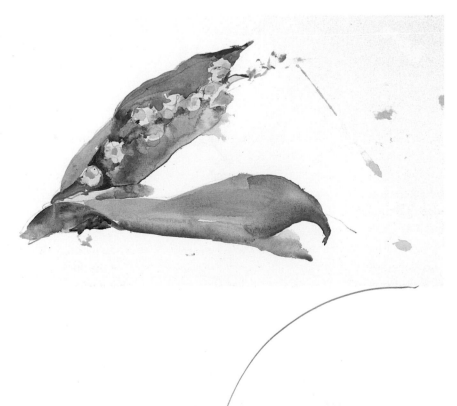

5: Paint some blush color and add some stems while trying to define some of the bleeding hearts with bits of dark green within the leaf. Be very careful not to overdefine. When you're through, add a cast shadow with a bit of blue when the leaf is still wet.

complicated leaf forms

Now let's paint a section of a gardenia plant. My gardenia is only suggested. You want a clean, fresh, uncluttered blush of white and light pink. Complicated leaf forms take patience. In this case the leaves form a pattern of darks and middarks with some distinct light leaf and flower boundaries. The trick is to keep some of these light boundaries firm and distinct while letting some of the darks and mid-darks blend. It's the old lost-and-found game that's essential in all painting.

You should make a considered contour drawing. The drawing will help you get centered in the right side of your brain. You can't indicate or suggest any compli-cated leaf form or pattern. Your drawing must be accurate. You're weaving darks and lights and midvalued colors. You're making an illusion of something that appears complicated. Paint it simply and carefully consider every edge and value relationship. Careful detail with firm edges in some parts and blurs in other parts makes a good painting.

Here you'll use a simplified gardenia, with some firm boundary edges along with soft, wet-in-wet borders in other places. The color you mix for your greens isn't important as long as you can make it rich and dark with your first try. Never start painting a white flower looking at the white flower. Always look for a darker leaf or flower shape next to the flower. Paint the dark and you'll have your white flower. This image is 8" x 6" (20cm x 15cm). You should use a no. 10 round sable brush on Fabriano Artistico 140-lb. (300gsm) cold-pressed or rough paper.

colors

Cadmium Orange
Cadmium Yellow Light
Cadmium Yellow Pale • Carmine
Cerulean Blue • Cobalt Blue
Ivory Black • Raw Sienna
Ultramarine Blue

1. Start at the top. Place your brush tip at the dry boundary of the dry flower. Define the outside shape of the flower with the darker leaf leaving some white paper. Don't isolate the gardenia with a fence of dark leaves.

Mix Carmine and a trace of Cadmium Orange and water for the off-white part of the flower. Paint this blush color on the left side of the gardenia. Leave a rim of dry white paper where you don't want the green to intrude. Continue painting your rich fluid, but not watery, greens so they can merge with the blush in the flower.

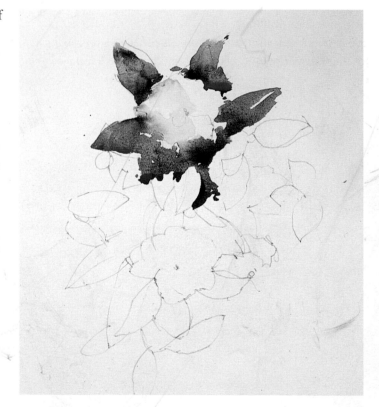

mixing colors

For this demonstration I won't use any premixed greens. Raw Sienna with one of the blues will work for a warmer green. Cerulean Blue and Cadmium Yellow Pale make a good cool light green. Try mixing Ivory Black with a little Cadmium Yellow for a dark green. Don't look for a formula: The colors I've listed are always on my palette and my brush goes to colors without conscious thought. You could add a premixed green of your choice. If the plant's leaves were generally warmer, I'd add Olive Green to my list. If the plant's leaves were cool, I'd add Hooker's Green.

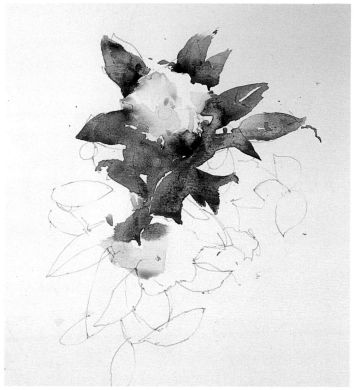

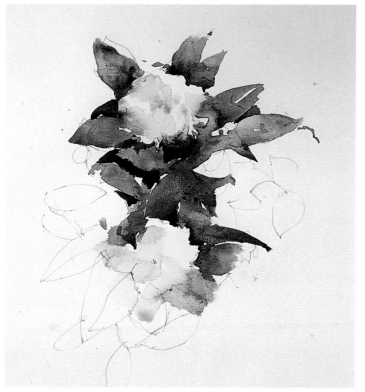

2: Paint some more leaves. Vary your shapes. Use your source colors rather than the mixing area. Experiment with warm and cool colors. You want definite separations and shapes but also a watery look with different greens and the flower mixing together. Leave rims and islands of dry paper where you see light. Create definite separations between dark and light.

3: Add the lower flower. You want rich darks and middarks running together with some separations and islands of light. Wait for everything you've painted to dry. Once dry, add some darker shapes.

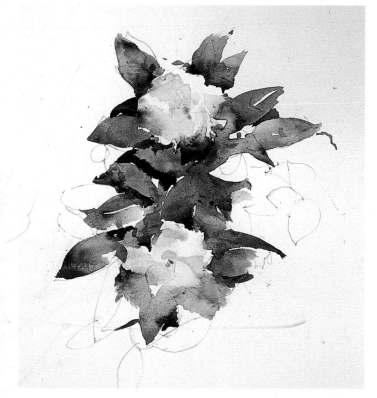

4: Finish the painting. Keep it fluid but defined with lost and found edges and evident color changes (because you didn't overmix on your palette but mixed colors and values on your paper). Don't overdefine. Try for 50 percent definition and 50 percent mystery.

COMBINING Leaves and stems

Now let's combine leaves and stems using the techniques you have already learned in the sections on brush work (pages 16-19) and medium leaf forms (pages 70-71).

colors

Hooker's Green • Olive Green
Oxide of Chromium or Sap Green

❊

painting tips

- Always make the light side of your subject the most important.

- Create value contrast and incompatible values in the light areas.

- Make your shadows simple with little value contrast and compatible values.

- Hard edges will usually be found in the light areas. If you squint and see a definite separation, you probably need a hard edge.

- If you squint and can't see a clear division of value, you need a soft edge.

- Make your edge decisions as you paint.

- It's difficult to soften a dried edge.

- Paint objects and cast shadows wet-in-wet. Cast shadows should begin at the base of a dark object.

- Use Cobalt and Ultramarine Blue for cool cast shadows and Raw Umber for warm cast shadows.

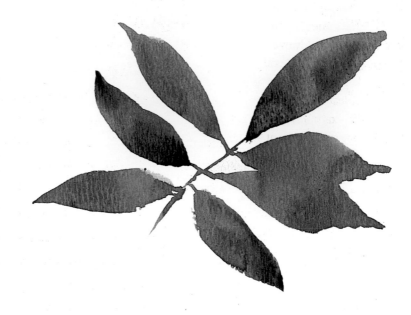

Painting Leaves and Stems
Make an arrangement of radiating, average leaves. Use a no. 8 or 10 round sable brush. Don't use a little brush for the connecting stems. Paint individual leaves. Allow two or more leaves to overlap. This will only work if you have enough paint and water on your brush.

cooler Leaves, a stem and a rose

Paint your flower form and adjoining stem and leaves at the same time. You may have to wait for a light or midvalue flower to dry if you want a firm edge. If you want a more watery look, paint the flower and adjoining stems and leaves at the same time. The rose in this example is a midvalued flower containing a fair amount of water, so it becomes tricky as you add the darker leaves. If the leaves and stem are too wet, too much dark color will invade the rose. Try to have just enough water in the darker forms to make them workable but not dry-brushed.

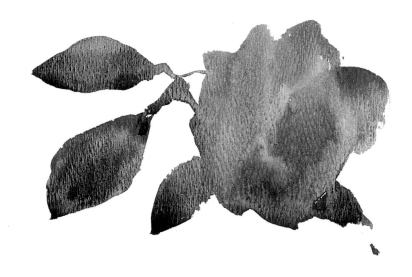

colors

Cadmium Yellow Light
Carmine • Ultramarine Blue

❀ Exercise

Combine a Rose With Leaves and Stems

Mix some Carmine and a little water. Give your brush a shake. Using a circular brushstroke make a pink blossom. For the adjacent stem and leaves, mix Ultramarine Blue with just a bit of Cadmium Yellow Light and very little water. Carefully form the leaves and stem. You don't want a major blur here, just a suggestion of a mix between the leaves, stems and flower.

Large, simple flowers—mums

I'm painting a bouquet of wilting purple and white mums. I didn't intend to paint wilting flowers but it's winter and good flowers can be hard to find. The best thing to do is to simplify and make it an exercise in painting good strong local color-value. I'm lucky to have these compact light and dark mums. Wilting daisies and other radiating flowers would be pretty hard to deal with.

colors

Cadmium Orange • Cadmium Yellow
Cadmium Yellow Light • Carmine
Cerulean Blue • Cobalt Blue
Mineral Violet • Olive Green
Raw Sienna • Sap Green
Ultramarine Blue

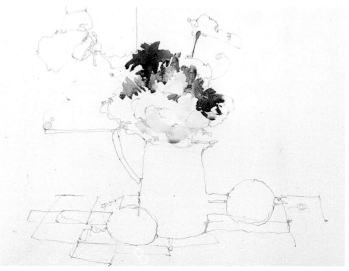

1: On dry paper, paint the darker leaves and flowers behind the white flower, working carefully around the specific petal shapes in the white flower. Use Mineral Violet in the flowers and Olive Green in the leaves. Allow the leaves and flowers to mix together. You'll need lots of paint and little water. A very light Carmine and Cerulean Blue wash is added to the flower. The edges of the petals should remain dry so you won't lose the white flower's boundaries.

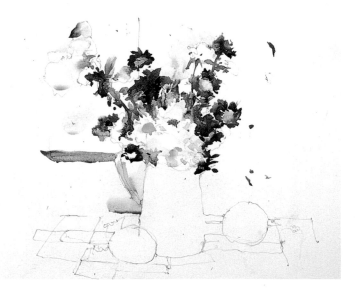

2: Paint more flowers and leaves. Add some Carmine and Cobalt and Ultramarine Blue to parts of the flowers. Allow some of the flowers and leaves to blend. Other parts should be dry before adding an adjacent color. Cadmium Yellow is used in the flower centers. Begin to paint a watery background using Cerulean Blue, Raw Sienna and Carmine to blur some of the flowers and leaves. Use the same diluted colors on the left side of the pitcher. The pitcher's handle is painted with a slightly darker version of the same colors. The cool strip is Cobalt Blue and Carmine.

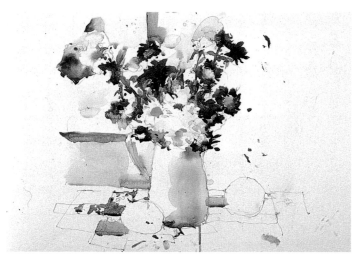

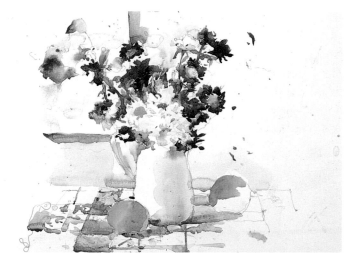

3: Use the same Carmine, Cerulean Blue and Raw Sienna to paint more background shapes. Change the ratio of colors and water to vary the values.

The pitcher's shadow starts off with Cerulean Blue at the halftone (the border where light and shadow meet). As you paint into the shadow, add Cadmium Yellow Light to show reflected color from the orange. Paint the patterned cloth using Cobalt Blue and Raw Sienna.

4: You want a watery pattern within relatively defined outer borders. Never paint a pattern like this on wet paper unless the whole painting is painted on wet paper. Try for varied color mixes with the Cobalt Blue, Raw Sienna and water. The pattern has low-intensity, quiet blues so use a pure Cerulean Blue to pep up the shadow under the pot and at the base of the orange on the left. Use Cadmium Yellow for the orange in the light area and Cadmium Orange with a touch of Raw Sienna in the shadow. Allow some orange to creep into its cast shadow and mix with the blue. Start your fruit with the light side first, as you'll see in the orange on the right.

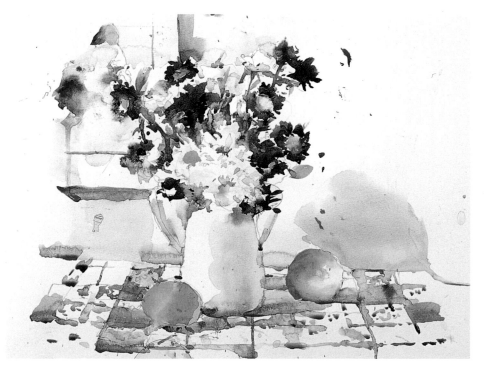

5: You don't want an exact repeat in your second orange, so leave the shadow side fairly light. Use Cerulean and Cobalt Blue in the cast shadows. Allow it to mix with the wet paint in the objects casting the shadows. This assures a color tie-in between the objects and their cast shadows. Wet the paper above the table on the left with clear water, then paint a cast shadow with Cobalt Blue, Carmine and Raw Sienna.

Large, Simple Flowers—Peonies

I've stressed four ideas: (1) Keep it simple; (2) always have specific detail in some areas and blurs and generalization in other areas; (3) always use rich and fluid paint in your darks and middarks; (4) allow the paint to do its thing; don't micromanage.

I overdid letting the paint do its thing in this example. I should have used less water in the peony. Still, I wanted you to see that it's OK to have runs and water marks in your paintings.

colors

Cadmium Yellow Light • Carmine
Cerulean Blue • Hooker's Green
Olive Green

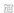

1: Always start a white flower with an adjacent dark. Never start with the white flower; you'll make it fussy with detail. Use Carmine and Olive Green, working wet-in-wet, in the red flower and leaves. The peony is dry. Paint carefully around the irregular peony boundary with your brush tip.

2: Add a very watery blush of Carmine and Cadmium Yellow Light to the peony, leaving some islands of dry white paper. Continue painting Olive Green down the left side of the peony. Add the pink flower under the peony. Add a pure color note of Cerulean Blue just for fun. Leave a jagged boundary of dry paper for the center section of the lower pink flower.

3: The water continues to do its thing and is out of control. Do not try to correct this by blotting or adding darker Carmine, you'll make a mess. Allow the lower pink flower to dry completely before you try to recover its boundary. Paint the lower section of the pink flower and add a bit of Olive Green next to it, wet-in-wet. Notice the puddle of Carmine on the lower lobe of the wet pink flower. Take a tip of pointed tissue and gently lift out any excess water. Otherwise you'll get a major watermark if it was the final outside boundary.

4: You should find some definition in the pink flower, but don't overpaint the whole pink flower even though there are light watermark mistakes. If you completely cover the offending flower with an overwash, you'll have an isolated and over-worked pink flower. It is not perfect, but there is a connection between the peony and pink flower. Very important—a very light wash of Cadmium Yellow Light is used for the centers of the pink flowers.

Use Hooker's Green, Cerulean Blue and Cadmium Yellow Light in different leaf sections. Never have a generic green in your mixing area. Always use both warm and cool greens. This will give you color temperature tie-ins with the warm and cool parts of your painting.

small massed forms—lilacs

You can't paint very small blossoms as individual flowers unless you have lots of time and are extremely skilled. It's better to pretend that the small blossoms are a large flower. You might need a photo to work from, so choose one that has definite light and shade.

Squint and notice that some sections of the flower grouping are lighter than other sections. Keeping the essence of light is hard when you have lots of little flowers and little bits of dark separating the blossoms. Small petal details and separations must be relatively light and you mustn't add too many. The best rule to follow is to keep it simple.

Darker leaves and stems help you judge your lighter values. No details in the light flowers should be as dark as the leaves. Never paint into a light valued area without comparing the light values in a flower with a dark leaf or flower. Compare the darker values you're adding within the flower to the dark leaf. Keep a tissue handy and be ready to blot darker values in the light flower. If the essence of the light flower is being destroyed, blot and stop adding details.

colors

Cadmium Orange
Cadmium Yellow Light • Carmine
Cerulean Blue • Cobalt Blue
Hooker's Green • Ivory Black
Raw Sienna

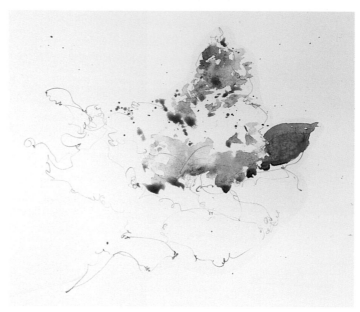

1: Mix a dark green leaf, making a good shape. This will be your value check. As you paint your light flowers, make sure that nothing in the flowers is as dark as the leaf.

Paint a midlight watery pink wash (don't overdo the water) with irregular edges and bits of light showing through. Use pure color from the tube with water to keep good color. Use pure Carmine in some places and then mix a bit of Cerulean Blue, Carmine and water in other parts. If you use Cerulean Blue, be careful it doesn't turn too gray. You may want to add a bit of watered Cadmium Orange to Carmine for light pinks.

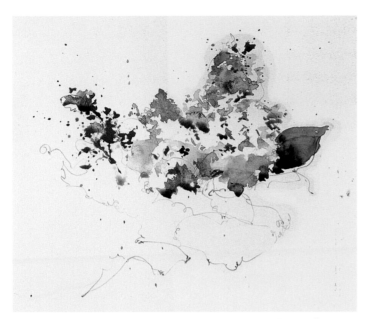

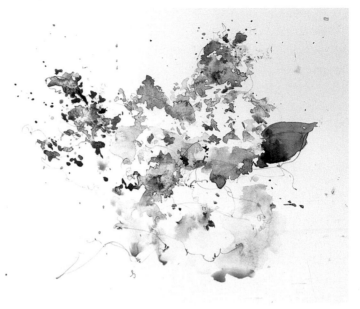

2: Place and lift your brush tip, painting up and away from the light shapes much of the time. Leave a section of white paper and add some midvalued small forms. Keep an eye on the leaf for your value check.

3: Add a bunch of white lilacs and some darker greens. Any dark green would work here, but make sure that some of the adjacent light pink flowers are wet. You want to create a combination of blended soft edges in contrast to some definite and precise edges.

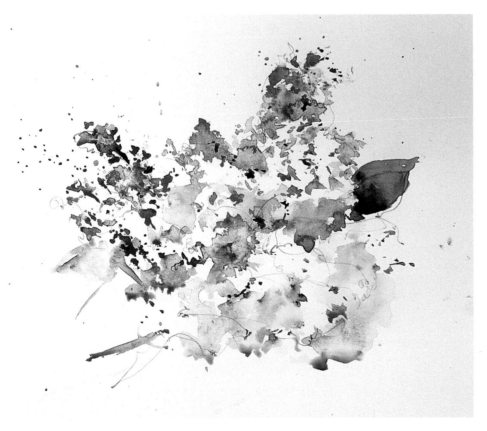

4: Define the underside of the lilacs and make a shadow shape using Cerulean Blue, Carmine, a yellow and Raw Sienna. Don't mix in the yellow or Raw Sienna at first. Try the blue and Carmine mix with a bit of water, then add a bit of Raw Sienna. Use Raw Sienna or Yellow Ochre as your mixing yellow; they are neutral yellows. Try not to define. It's best to keep the mystery.

Nasturtiums

Use pure color right from the start. The yellows and reds come directly from the color supply with only a brief stop and a minimum of mixing on the palette. Very little water is used, just enough to keep the paint moving. Don't feel you must contain your flowers with firm defined boundaries. In places, you should release flowers, letting them work together and flow out into the background. Although I've made a fairly careful drawing, I don't always stay within the pencil outline. Use your nos. 8 and 10 round sable brushes.

colors

Cadmium Red • Cadmium Yellow
Cadmium Yellow Light
Cadmium Yellow Pale
Carmine • Cerulean Blue
Cobalt Blue

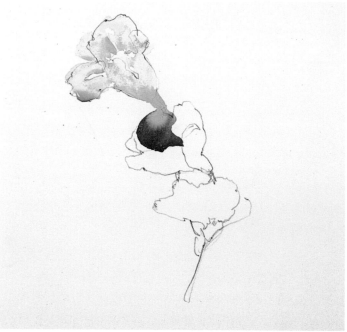

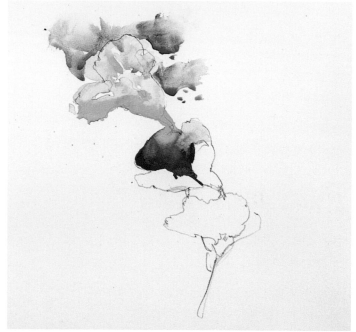

1: Develop form in the yellow flower right from the start to preserve the delicate freshness of the yellow flower. The islands of dry white paper stop the yellow wash in places, creating slightly darker sections. Use Cadmium Yellow for a darker yellow value and Cadmium Yellow Light or Pale for the lighter yellow. Cerulean Blue is mixed on the palette with Cadmium Yellow for darker parts of the yellow flower. While the yellow flower is still wet, use Cadmium Red to start the red flower. The bleed looks a bit dramatic, but you don't want to isolate each individual flower.

2: Give the inside of the red flower some definite shape. Let a little diluted Carmine into the upper right petal to lighten it. Be careful when adding watery washes to still wet areas—the water can create havoc. Paint some areas of background but don't isolate the flowers. Paint around the yellow flower with flat, solid color. There should be value differences where the background meets the flower. Don't always paint parallel with the petals. Make some strokes that are perpendicular to the petals.

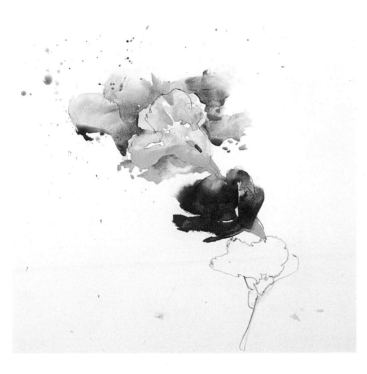

3. A strong red with no water is need-
ed to absorb the watery Carmine in
the inside of the red flower. Leave the out-
side petals light. Leave some dry white
paper in the red flower to capture some
darks. Give each petal an individual char-
acter with single careful brushstrokes. You
want some blurs but you also want preci-
sion. You should see traces of brushstrokes
within the flower; it's a good sign that
you're not overworking. The outside
boundaries of the background color
should be watery and suggest a casual
design. Avoid scratchy dry-brush endings
in your background. They look awful.

4. Add another red flower, stems and
more background. Try to keep the
watery look but still keep parts that are
definite and precise. You also need lots of
water and lots of moist paint. I may have
been too strong with the Cerulean Blue. I
hate dead overmixed color and sometimes
overuse pure color.

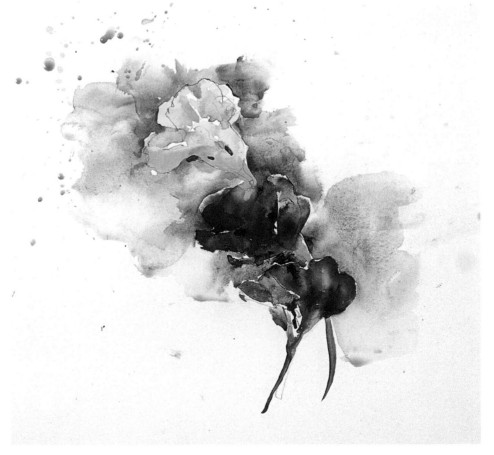

tip

If you add too much water, the best first aid
is pigment direct from your paint supply.
Have a tissue handy to delicately dab if
necessary.

A RED CACTUS DAHLIA

Dahlias come in a variety of flower shapes, colors and sizes. We'll start with the simplest, the red cactus. I've painted each step individually so you won't see an exact transition from step to step. I used photographs as my reference. Never worry about using photographs; they can save time, giving you an instant reference for practice.

colors

Alizarin Crimson or Carmine

1: Load a no. 6 round sable brush with Carmine or Alizarin Crimson. The paint should be rich and fluid. Place the tip of your brush at the tip of a petal. The brush should be at a 35° angle with the paper. The side of your brush hand should be resting on the paper. Make your strokes with a firm wrist. Paint single strokes, keeping the brush on the paper and painting from petal tip to base.

2: Continue beginning your stroke at the petal tip. You want a pure Carmine or Alizarin Crimson, so go to the water, shake and then go to the color supply for fresh paint. If you mix Alizarin Crimson and water in the mixing area, you may have too much water and your petals may lose their spunk. The center of the flower should be lighter than the tips.

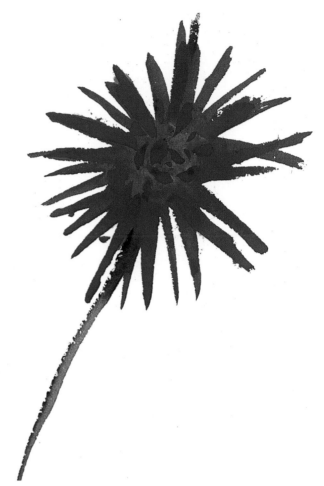

3. Paint up to twelve o'clock with the same stroke. Now start two or three petals at the center of the flower and paint out to the petal tips. Then make two or three petals, starting at the tip and painting back to the center. Don't dab or fuss. Keep good paint consistency for subtle value variations within the flower. Add the stem using any pure dark green.

4. Let your flower dry for a few minutes. You should make several others while you are waiting. Adding the second darker value needs timing. Try adding when the paint is a bit damp on one flower and when it's almost dry on another.

Dip the tip of your brush in the Alizarin Crimson or Carmine, and starting about ½" (1cm) from the center, make some darker petals. Repaint just a few of the petals around the center and then add some dark dots and short strokes in the center.

Review the section on brush work (pages 16-19). It's important to remember to start your strokes at each end of the petals in dahlias and similar flower forms that have definite petal shapes.

colors

Alizarin Crimson • Cadmium Yellow Pale
Carmine • Cerulean Blue

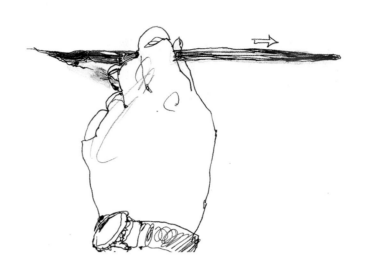

Brush Work
The hardest part of painting a dahlia is making a horizontal petal. You have to swivel your wrist in an awkward fashion. It takes some practice.

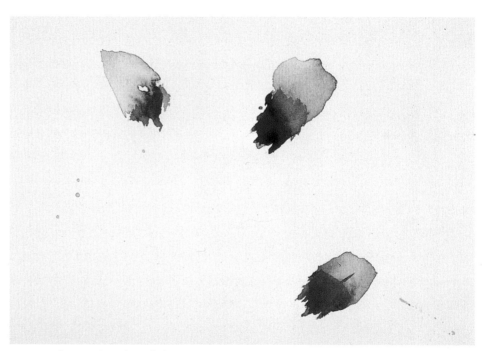

1: Make a series of petal shapes using your no. 8 round sable brush. You want a very light petal tip with a medium-dark base. Mix a bit of Carmine with some water in your mixing area. You want just a blush of color. Rinse your brush and give it a good shake. If there's lots of water in the mixing area, you may have to blot your brush with tissue. Start a stroke at the petal's tip with a very light wash and go about halfway down the petal. Go back to the Carmine in the paint supply and brush back from the petal's base into the damp light wash. Try several then reverse the process, starting at the base with Carmine, going up about a third of the way, stopping, rinsing and painting back with your light wash until you meet up with the Carmine. These three examples are all different and imperfect. Some of your petals won't be perfect. Just keep trying.

2. Make a pencil circle for the center of your flower. Paint a series of petals around your center. Vary your method by sometimes starting at the base; sometimes starting at the tip of the petal.

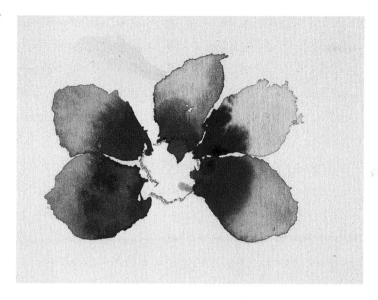

3. Let your petals dry. Add Cadmium Yellow Pale in the center. Now add some darker green background shapes to bring the flower into focus. Don't paint your background in a solid rim around your flowers. Vary your brush work in the green background. Sometimes make it parallel with the petal; sometimes use a perpendicular or angular stroke. If you're fading into white paper, make sure you have a watery lightvalued boundary. Avoid dry-brush, abrupt and scratchy boundaries.

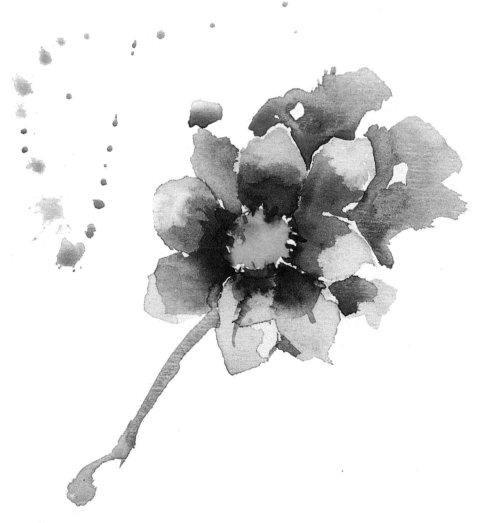

watery dahlia

Sometimes you're so keen to paint a flower accurately you become tight and literal. This is a real danger when working from photographs; there's just too much accurate information to study.

The trick is to allow your paint and a little water to do the painting. Most people never stop to watch the paint and water work. So many wonderful things can happen if only you'd put your brush down and let your painting be your teacher.

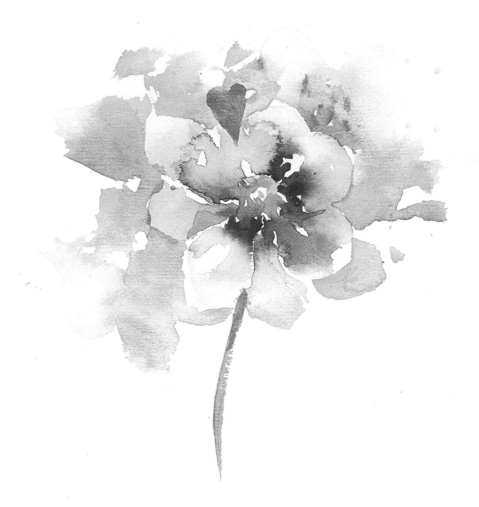

🌼 Exercise
Experiment With Different Water Ratios

Plan to make several flowers. Follow the directions from the other dahlias you've already done. This time experiment with different water-paint ratios. Vary the waiting time before adding an adjacent color or wash.

Allow washes to intermingle. You can go back with a midvalue *definer*, a shape that brings a blur into focus.

I let the background green seep into the top of my flower. I watched, with fascination, the workings of watercolor paint. I let it dry without a dab of tissue or brush. When it was dry, I added a definer shape. It's in the shape of a heart.

Yellow Anemone Dahlia

Yellow is a hard color to darken without making a color change (darkening with green or blue) or going too warm and dull (darkening with Raw Sienna).

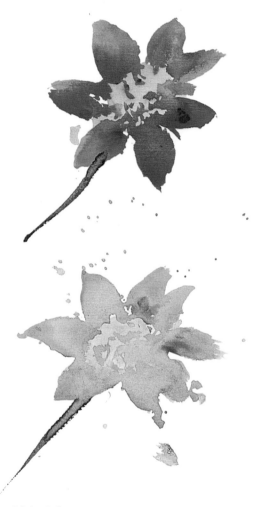

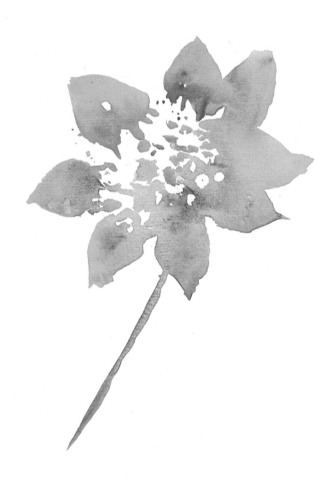

Choosing the Right Color
For the top flower I used Cadmium Yellow Light for the lighter parts and Raw Sienna for the darker parts. The flower is too warm and dull. I am not happy with the colors and my painting looks stiff and rigid.

For the lower flower, I again used Cadmium Yellow Light for the lights but switched to Cerulean Blue to darken. It's a better flower. I used a bit more water and was "looser" in my painting, but it's gone too green.

Let Color and Negative Space Form Your Flower
I used Cadmium Yellow Light for the lighter parts, but I mixed a little of the Cerulean Blue with a lesser amount of Raw Sienna in my mixing area. I decided not to make a big deal of showing definite darks in parts of the flower and allowed the paint more freedom to mix on the paper. Don't use too much water.

A ROSE—COMBINING SMALL AND LARGE SHAPES

A rose is a large form made of many small forms. It's easy to see a large form in an unopened budding rose. This demonstration shows such a rose with a large center section and two thinner petals. The large opened rose is created from separate strokes used to make a variety of specific shapes. Try to identify the larger shapes from the smaller ones. Students often have a hard time seeing and painting specific shapes. Work on this; don't accept quick shorthand indications. Lose yourself in concentration and practice the brush work that will bring your concentration to the paper.

In this exercise, I've tried to go from a simple flower on the top to a flower in the middle that showed some of the makings of a rose to the more finished and complete flower at the bottom.

colors
Carmine • Olive Green

brushes
No. 10 round sable brush

1: Mix some Carmine in your mixing area. Make a large pink shape and immediately go to your color supply and add pure Carmine with very little water to the base of the flower and to the upper lobe. The initial shape is quite wet so it's tricky and will take some repeats. Add the side petals with Carmine and little water, and then add the Olive Green stem. All of this is done wet-in-wet.

2: Look for darker shapes in the opened rose. Don't think of a single flower but rather darker specific shapes that will be the foundation for your rose. Darker petal shapes should be dry before adding lighter adjoining petals. If adjoining petals are both midvalue, paint them together.

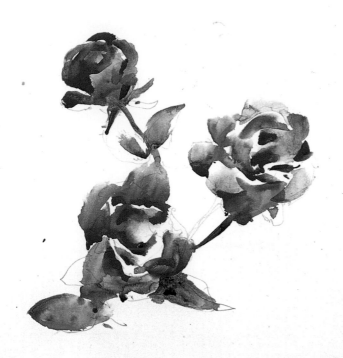

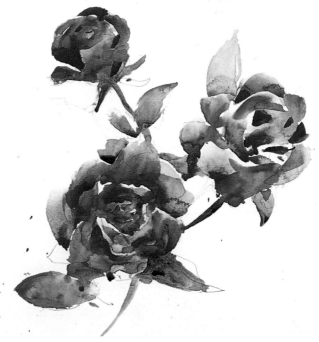

3: Fancy brush work, good paint consistency, seeing and painting specific shapes and knowing when a petal is dry enough to add a dark make this a tough exercise.

In this step, leave carefully shaped islands and peninsulas of dry paper and allow midvalued and darker Carmine shapes to form the rose. When the top rose is completely dry, carefully add darker shapes of Carmine. Never add a complement to an overwash. The cleaner and purer the overwash the better.

4: Paint more flower shapes, adding stems and leaves. The last part is always the hardest part. It's time to go very slowly. Add a stroke and sit back. Never add more than one stroke when you've run out of ideas.

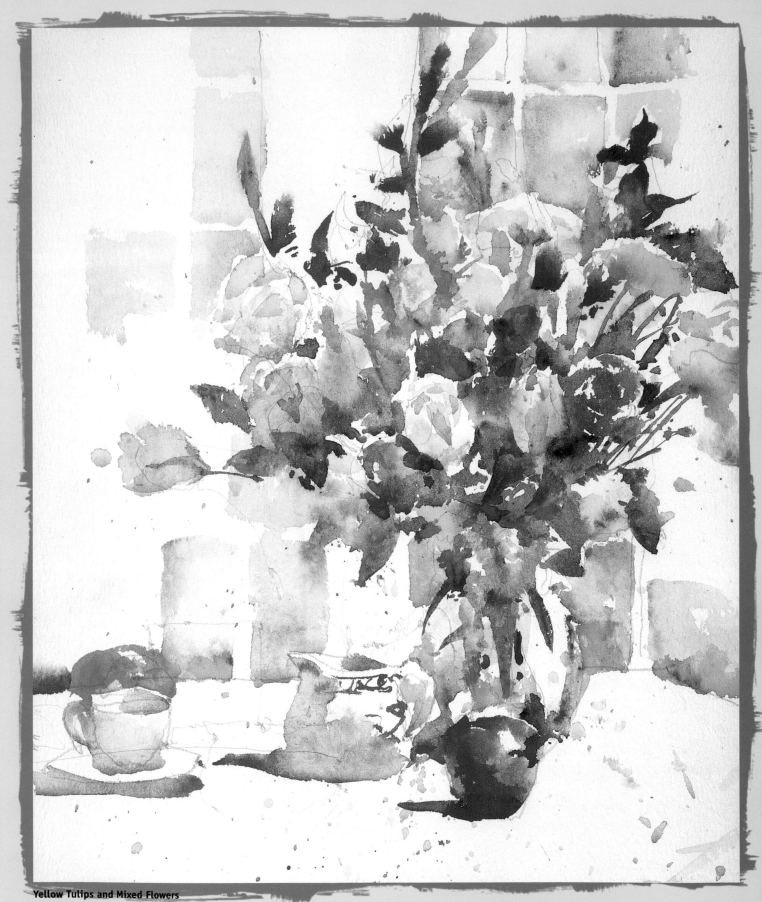

Yellow Tulips and Mixed Flowers
Watercolor on Fabriano
 Artistico 140-lb. (300gsm) Paper
20" x 16" (51cm x 41cm)
Collection of Sandra Smith

Advanced Step-by-Step Demonstrations

HOPEFULLY YOU'VE PRACTICED THE EXERCISES IN SECTION 2 AND understand local value. These demonstrations may be difficult to follow if you haven't done the previous work. If you've painted a lot, I hope you'll find some ideas that you can incorporate into your own style. If you're new to painting, don't worry about copying my style. Your own personal style will happen the more you paint. All painters are products of who went before. My style happened but I've copied other painters shamelessly. Don't limit yourself to "how to" books like this one. I got my color mixing and direct painting ideas from Sargent and De Koonig. Simplicity and color ideas come from Diebenkorn, Porter, Rothko, and Matisse. Composition comes from Vuillard and Bonnard. And one of my favorite watercolorists is Andrew Wyeth. Truly a mixed bag. Good luck and happy, but challenging, painting.

SIMPLIFIED LILACS

Let's begin with simplified lilacs. I've left the white paper for the background so you'll have one less problem to solve. The coffeepot holding the flowers has been separated into a light side and a shadow side. I've left the dividing light-shadow edge hard so you'll be sure to paint clear light and shadow sections.

colors

Burnt Umber • Cadmium Yellow Light
Carmine • Cerulean Blue • Cobalt Blue
Yellow Green

brushes

Nos. 6, 8 and 10 round sables

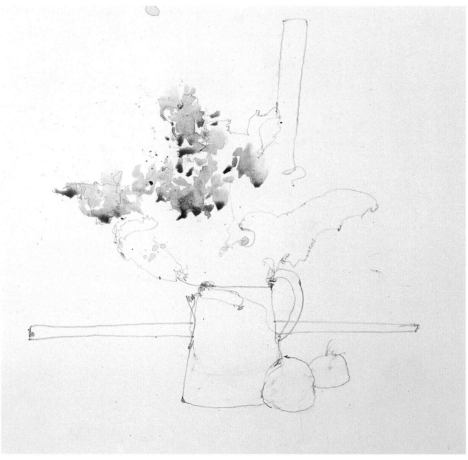

creative coloring

Are you wondering how to give life to the dull and nondescript? I think of colors that might look good. The window frames in my studio are actually dark, dull black. In step 3, I've painted my window frames with Cobalt Blue on the upper frame and Cobalt Blue and Burnt Umber on the left frame. These are imagined colors; I'm try-ing to find color tie-ins with other parts of the painting. I lightened the window frames so they wouldn't overpower the light values in the pot and flowers. Never paint homogenized grays for parts of a painting that don't seem important.

1. Gather sections of the small blossoms into groupings of light, midvalue blues and Carmine. Paint on dry paper, placing your brush with short abrupt stokes. Make sure you leave dry white islands between your strokes. Notice the still-wet paint is gath-ering at the bottoms of the blossom shapes.

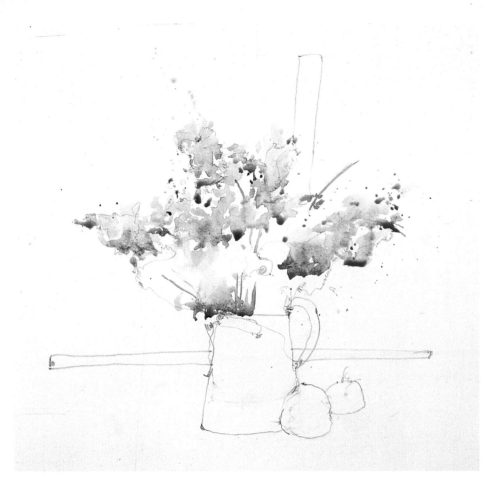

2. Paint the shadow undersides of the lilacs using Cerulean Blue. Now leave an irregular band of dry white paper and add some more light, midvalue lilacs in the lower left. Soften some parts of the lilacs by brushing from the white paper into the lilacs with a damp to wet brush (rinse your brush and give it a good shake). Rinse your brush and add very light Carmine from the mixing area for softening. Make darker "spatter" spots, using your blues and Carmine (see Brush Work page 16-19). Form the top rim of the coffeepot with some light, midvalued blues and Carmine. Add the green stems using a mix of Cadmium Yellow Light and Cerulean Blue. You want a sense of wet and fluid flowers along with specific and hard edges.

3. It's time to add some darker window frames to connect the flowers to the picture borders, and to paint the shadow shape on the coffeepot. Paint the upper window frames with Cobalt Blue. Use Cobalt Blue and Burnt Umber for the window frame on the left.

Start the upper part of the coffeepot's shadow with Cerulean Blue and Carmine. Remember to always start your shadow where the shadow meets the light. Make sure you don't make the shadow too dark. As you work down and to the right, add some diluted yellow to show the apple's reflected color.

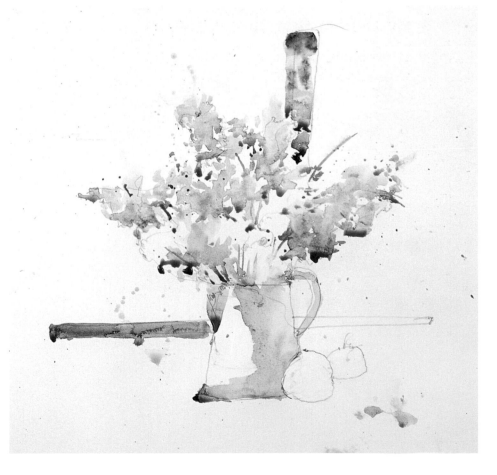

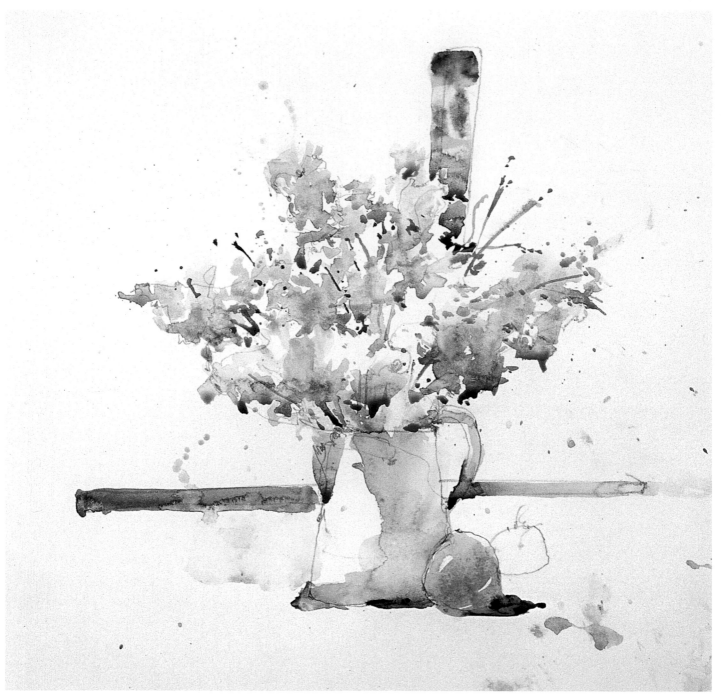

4. Add undiluted Cobalt Blue for the dark at the base of the pot. When the pot's
shadow is dry, paint the apple with Cerulean Blue and Cadmium Yellow Light,
leaving a highlight. Add Cobalt Blue and the yellow in the apple's shadow. With the
apple still wet, add its Cobalt Blue cast shadow.

Paint the window frame on the right with Cobalt Blue. Allow it to blend a bit with
the pot's handle.

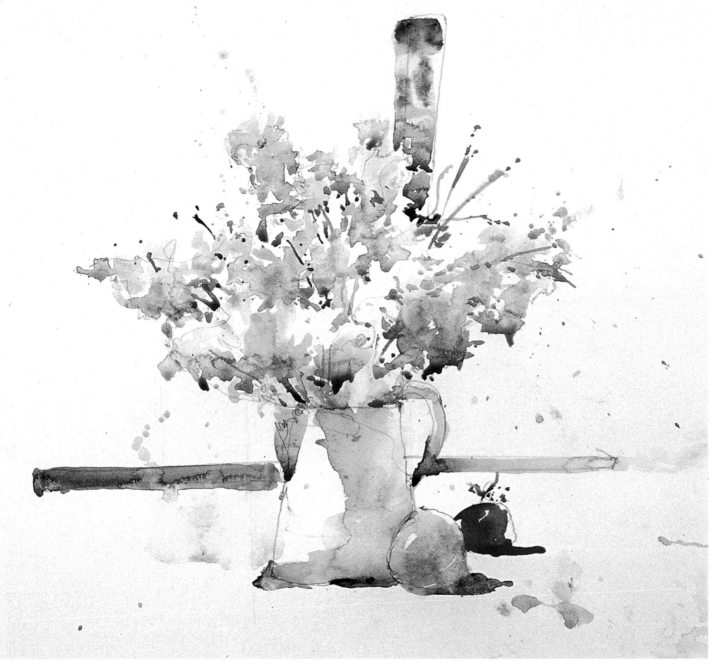

5: All that needs to be done is the tomato. Paint slightly diluted Carmine in the tomato and full strength Carmine in the cast shadow. Paint the tomato and cast shadow at the same time.

Simplified Lilacs
Watercolor on Fabriano Artistico Cold-Pressed
140-lb. (300gsm) Paper.
12" x 12" (30cm x 30 cm)
Courtesy of Munson Gallery

ROSES WITH BACKLIGHTING

Here I am painting roses, which give me large shapes to work with. I like backlighting. It simplifies the flowers and objects into flat shapes with rim lighting. The larger and simpler the shapes, the more successful the painting will be.

It's difficult to capture the values you see in backlighting and still keep the feeling of light and luminosity in the flowers, objects and window frame. If you paint what you see, the flowers and window may be too dark. On the other hand, if you lighten your interior values too much, you'll lose the wonderful simple silhouette shapes of light and dark typical in backlighting situations.

colors

Burnt Umber • Cadmium Orange
Cadmium Red Light • Cadmium Yellow
Cadmium Yellow Light • Carmine
Cerulean Blue • Cobalt Blue • Lemon
Olive Green • Raw Sienna
Ultramarine Blue

brushes

Nos. 6, 8 and 10 round sable brushes

actual colors

The actual colors might seem important to you but they really aren't very important. The importance is in the mixing or, more important, in the undermixing. Whatever colors you use, you need to keep luminous values and color differences in each part of your picture. I use the same colors over and over again but I mix on the paper and change the ratios of blue, Carmine, yellow/orange and Raw Sienna in each part of the painting.

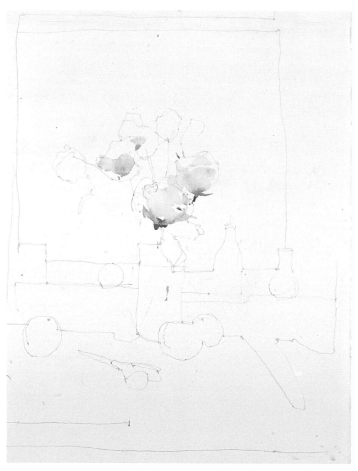

1: You want the roses to be a lovely mix of very pale pinks, oranges and warm yellows. Put intersecting patches of diluted Carmine, Cadmium Orange and Cadmium Yellow Light in your mixing area. Don't mix them all together; you should still be able to see traces of the individual colors when you've finished this step. You want the colors to mostly mix on the paper. Use Carmine and Cadmium Orange hardly mixed for the lower blossoms; you should still see bits of the orange and Carmine. The upper blossom is Cadmium Yellow. Add Olive Green stems while the blossoms are still wet.

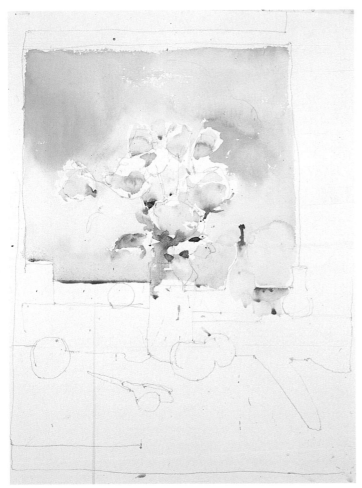

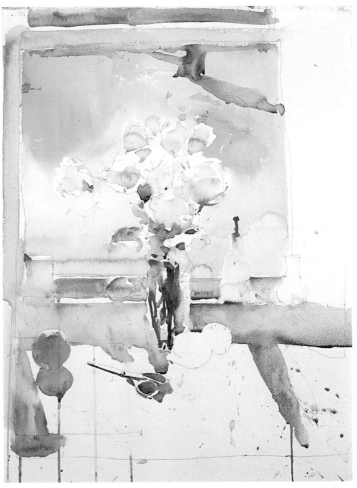

2: The flowers are blotches of diluted but evident color with bits of light, dry white paper on the upper parts of the petals. To help define the light flowers, quickly paint the lawn behind them. Try to keep the grass light but rich in color without losing the strong darks and lights. Use the same Cadmium Yellow Light you used in the flower with diluted Cerulean Blue for the lawn. It will be a good color tie-in. Add more leaves and the top of the olive oil bottle. Try to keep these early stages fluid with as much wet-in-wet painting as possible. Keep some firm edges where light and shadow meet.

3: Add the tree trunk to create a background dark to balance your foreground darks. Use Carmine, Cobalt Blue and Raw Sienna in the window frame, Cadmium Yellow Light in the mustard on the left, Cadmium Red in the apple and Raw Sienna and Cadmium Orange in the orange with Cobalt Blue added for the orange's cast shadow.

Paint more cast shadows and more of the window frame. Allow the colors to mix on the paper. Paint the shadows in the scissors first with Cadmium Orange and Raw Sienna. The cast shadow under the scissors blades and inside the handle opening is Cobalt Blue. When the mustard jar is dry, paint the stems in the flowers carefully with attention to shape. You should have a combination of definite and blurred stems.

You may see a watermark along the upper edge of the left window frame. This might drive you crazy, but try to let accidents happen and learn form them.

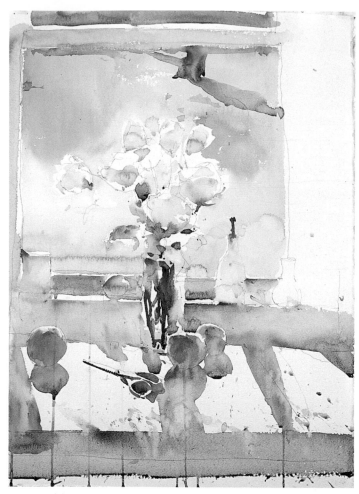

4: Add the green apple and lemon, concentrating on local color-value. Leave dry white paper for the top rim lighting. Once the shadows in the fruit are dry, add a very light green and yellow. Darken the center of the apple, leaving a lighter bottom to show bounced light before adding the cast shadows. Finish painting the window frames. The shadows and cast shadows should be allowed to merge.

Paint What You See

After completing my painting, I went back and created this sketch. I should have painted this before I completed the painting in this demonstration. I have strong sunlight outside. I've gone a bit too dark, but these are close to the values I actually see. I should have made my window frame and interior shadows and cast shadows a bit darker. Even though I prefer this sketch to my final painting, I definitely would not restate the window and shadows with a darker overwash. It's much better to put my disappointment away and make another painting with stronger value contrasts. This sketch could make a good painting; in fact, my final painting looks pretty wimpy in comparison.

merging shadows

You want the boundaries in shadow to merge and become "lost." When shadows meet the light, they should be hard edged. Edges out in the light are almost always more definite and clear than edges in shadow. The closer the cast shadow is to its object, the more definite the edge.

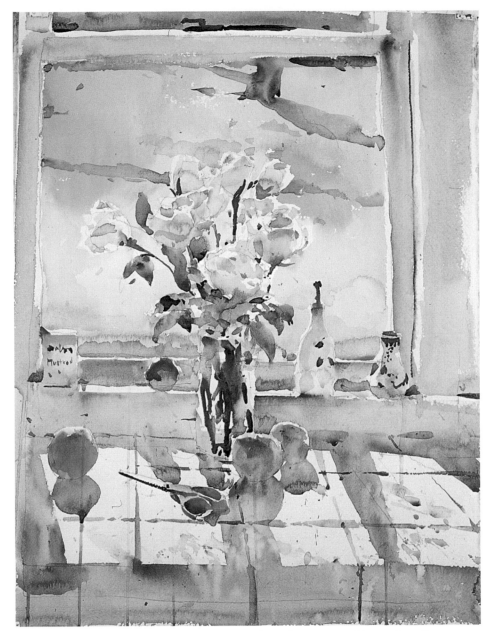

5: Add some darker pattern details in the olive oil jar, mustard jar and small vase on the left. Paint the stripes in the tablecloth.

I've made my shadows too light. The roses are okay, but the window frame, shadows, and cast shadows should be at least a value darker. I like to show light and air in my darks but I overdid it. I've accepted this as a less-than-perfect painting that we can learn from. I would never restate my shadows. The second wash always looks muddy. I would never add additional darks. A few may help but rarely does adding dark darks help a weak picture. Usually the added darks look out of context and make the painting look spotty and fragmented.

silvermine STILL LIFE

This painting was done as a demonstration for a flower painting class. I've tried to cover some of the problems I noticed including (1) using too much water and not enough paint; (2) painting isolated flowers and allowing them to dry without connection with adjacent leaves or flowers; (3) using homogenized puddle color instead of fresh paint from the color supply; (4) filling in vases, bottles and fruit as solid shapes; (5) not adding cast shadows at the same time the object casting the shadow is painted.

colors

Burnt Sienna • Burnt Umber
Cadmium Orange • Cadmium Red
Cadmium Yellow
Cadmium Yellow Light
Cadmium Yellow Pale • Carmine
Cerulean Blue • Cobalt Blue
Ivory Black • Mineral Violet
Olive Green • Raw Sienna • Raw Umber
Ultramarine Blue

brushes

Nos. 8, 10 and 12 round sables

too many greens

Be careful not to fill in too many greens too early. You can always add greens but you can't take them out. If you have difficulty with this, draw in areas of green with slight shading or do a color-value sketch before painting. Plan your greens.

1: Make a contour drawing. The outside silhouette of the bouquet is important. Draw some blossoms but not every blossom. If your drawing is too exact, you might find yourself filling in outlines. As you contour, you're getting used to leaving out boundaries and working inside as well as outside the things you're going to paint.

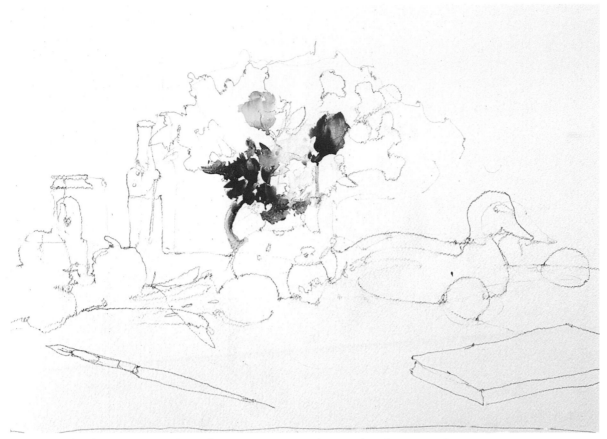

2: Decide where you want clean, clear contrasts around your white flowers. Make sure your drawing has good specific shapes in the white flowers. Use Cadmium Red, Cadmium Yellow and Olive Green directly from the paint supply for the flowers and greens. The vase handle is Cerulean Blue. The most important point here is not what colors you use but rather how strong and intense the colors are and how you let them mix together, wet-in-wet on the paper.

Bring diluted Cerulean Blue, Cadmium Yellow and Carmine to the mixing area, and paint from the white flowers into the background to form the subtle darker parts of the white flowers. Do not mix the three together. You'll need to experiment with different ratios of the three colors and water. You should always see traces of each color in your mixing area. You should never see a homogenized gray. Next add your green against your light shadow value and let them mix on their own.

squint to find value connections

Never stop the flowers because they meet the vase and you know these are flowers and now you have to start the vase. Forget the identity of what you're painting. Squint and find value connections and separations. I'm painting a glass vase with stems and highlights. Try not to think of the outside boundary of a transparent vase. Look inside and find the shape in the water level, and the stems and reflections and highlights in the vase.

3. Leave a section of white paper and then add carefully formed blotches of diluted Cerulean Blue, Carmine and Mineral Violet along the top. Use pure diluted color. You should see the "makings" of the flower blotches, bits of blue, Carmine and Mineral Violet.

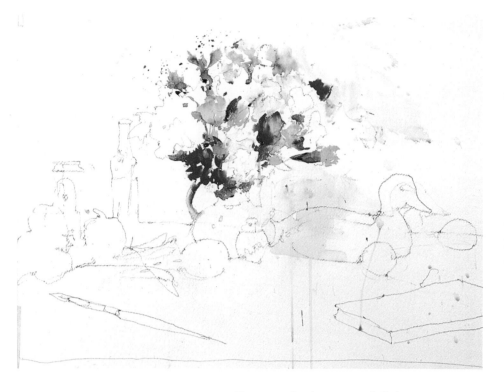

4. Squint to see a definite contrast between lights and darks to help you isolate your whites and light flowers. Add more flowers using pure color and letting areas of similar value blend. Move down into the vase. Don't make a separation between the vase and flowers unless you see a value separation. There are a lightvalued lemon and mustard jar in front of the vase. Find darks behind them before painting them. Squint to find your contrasts. Make sure you don't let darks from the vase into the light part of the lemon and jar. Let a little shadow color into the vase. This is similar to how you connected the shadows in the white flowers. Leave the light part of the lemon against the darker values in the vase as dry white paper. You will add Cadmium Yellow Pale later when the darks in the vase are dry. Paint the shadow side of the lemon with Cadmium Yellow, adding a cast shadow of Cobalt Blue.

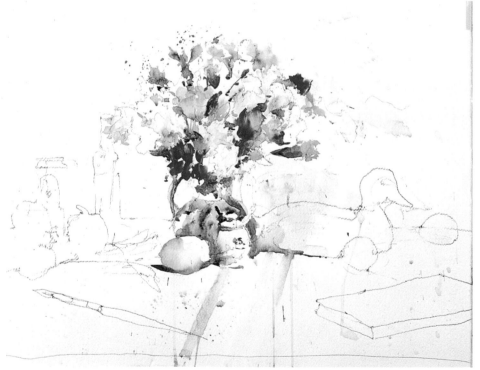

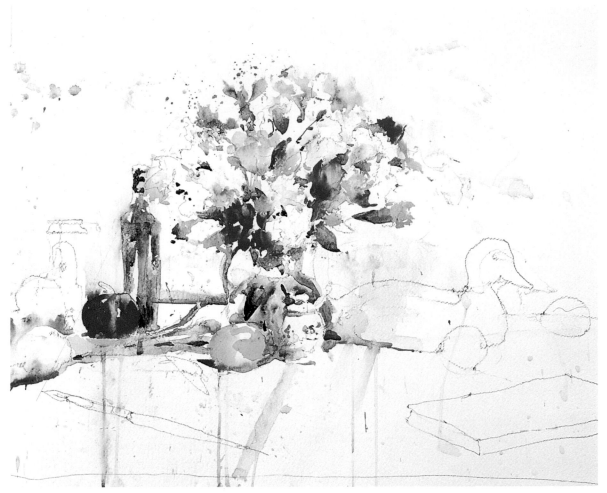

5. When the vase is dry, paint the light side of the lemon with intense Cadmium Yellow. As I work to the left, a strip of Cobalt Blue connects the vase to the olive oil bottle. The brush's tip, loaded with paint, runs along the edge of the table, while the body of the brush, with less paint and more water, makes a softer and lighter upper edge. Press the no. 10 brush about halfway to the metal ferrule and make one continuous stroke. Keep some white paper reflections in the bottle so it won't be a flat, static shape. Use both warm and cool colors in the bottle and vase so they will relate to the warm and cool colors in other parts of your painting. Use Raw Sienna and Cobalt Blue in the bottle. Notice the yellow flower overlapping the top of the bottle. This gives a connection between the flowers and the bottle. Paint the apple Carmine and Cadmium Red. Add the green onion stems using Cadmium Yellow Pale and Cerulean Blue with Cobalt Blue in the cast shadow under the onion's bulb.

save your whites and light areas

Add places for whites and light colorful passages in your pictures regardless of the actual flower arrangement. A bouquet that may look great may not translate well into painting if it has too many greens. Try not to think of painting specific flowers; you'll probably tighten up and use the point of your brush and try to render the petals and specific details. You'll ruin your brush and probably have a dry and weak painting that will look terrible from a distance. Every good painting should look good from 20' (6m) away, so never judge your picture close up.

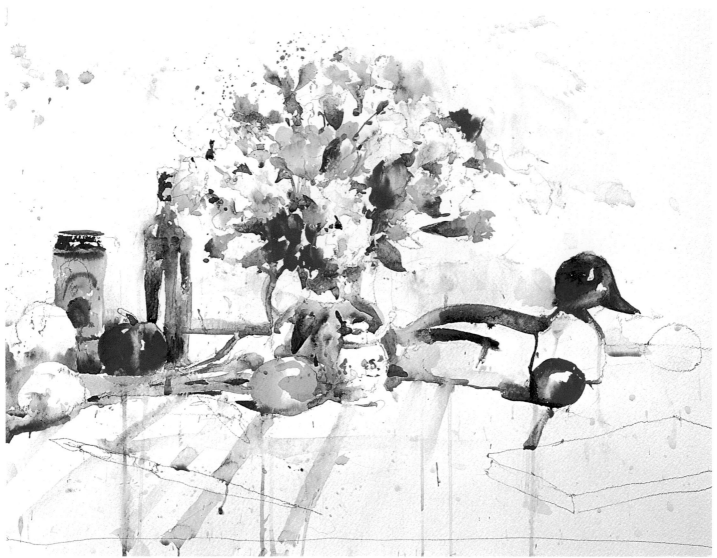

6: Paint the beer can using Cadmium Yellow and Raw Sienna with Ivory Black in the trim. Adding this to the background brings the second onion into focus. The onion should be dry white paper toward the top but damp at its base so color from the beer can will seep in. Paint the decoy's head with Ultramarine Blue and Burnt Umber. As you paint to the left along the duck's back, your darks should lighten causing the tail area to recede and disappear behind the vase. You want the viewer to look from the flowers to the duck's head and apple and out the right side of the picture. Paint the apple using a strong Cadmium Red. Cobalt Blue makes for a good cast shadow. Leave some white paper and hard edges in the apple for highlights.

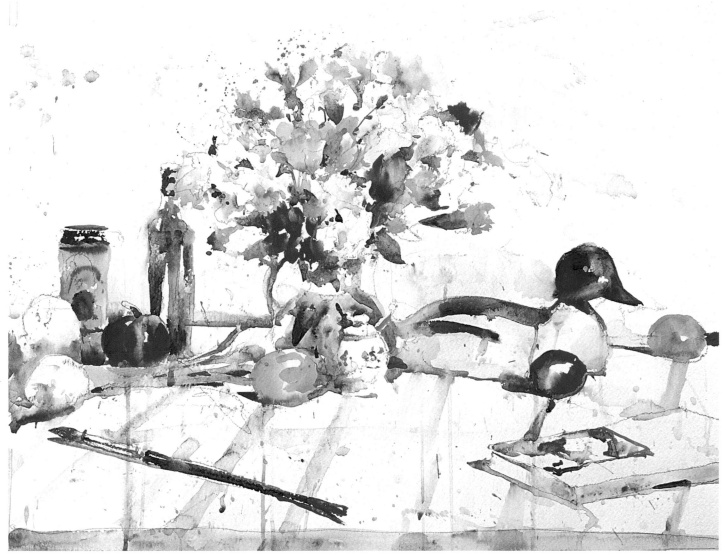

7: Use tissue to remove any drips like the one above my apple.
Paint the green apple with Cerulean Blue and Cadmium
Yellow Pale. Place a Cobalt Blue cast shadow and a Burnt Sienna
accent to the right of the apple. Use diluted versions of the same
colors in the book. The stripes are diluted Cobalt Blue. Paint the
drips on dry paper but try to do them when some of the objects
are still wet so you'll get runs from the objects into the stripes.
You want to paint the object, cast shadow and any connecting
shapes and strips as you move across the paper. Paint the brush
handle Ivory Black and Cadmium Red at the tip with a Cobalt
Blue cast shadow. The tip of the brush is Raw Sienna and Burnt
Umber. Use some stripe color and water to help soften the rigid
brush handle.

Silvermine Still Life
Watercolor on Fabriano Artistico Rough 140-lb.
 (300gsm) Paper
18" x 21" (46cm x 53cm)
Courtesy of Munson Gallery

A SUNFLOWER WITH A MIXED BOUQUET

I've started with pure Cadmium Yellow from my paint supply for the sunflower. You don't have to be too careful with the shape of the sunflower. The important thing is to make the shape large enough. Your colorful blossom shapes should always dominate the greens. Too often the leaves and stems take over. I often cheat and add more blossoms than are actually in the bouquet in front of me. It would be okay to leave these yellow flowers as white paper and start with the adjacent darker greens, but you'd have to be very careful with shapes in the greens. And there's the danger of making the edges too hard in your effort to be accurate. I think starting with the yellow is the safest approach.

colors

Burnt Sienna • Burnt Umber
Cadmium Red • Cadmium Yellow
Cadmium Yellow Light
Cadmium Yellow Pale • Carmine
Cerulean Blue • Cobalt Blue
Ivory Black • Olive Green
Raw Sienna • Raw Umber
Ultramarine Blue

brushes

Nos. 8 and 10 round sables

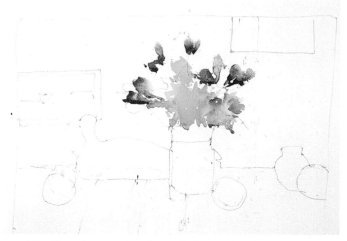

1. Start with Cadmium Yellow for the sunflower making it a bit larger than it actually is. Try for petal shapes around the outside edges of the flower; don't worry too much about being accurate. You will "find" the actual shapes later when adding adjacent darks. Do not try to show the individual petals within the flower. While the yellow is still wet, add a second flower with diluted Carmine, allowing it to blend with the first flower. Add a stem of Olive Green on the left, making a soft edge.

2. Use Carmine to paint the pink flowers by placing the loaded brush tip at the base of the blossoms and then pressing with the body of the brush, which contains more paint. Place the point carefully, pressing and then lifting. You'll need a no. 10 round sable to manage this. Don't stroke.

While the pink blossoms are still wet, add stems of Olive Green. The stems shouldn't be too watery. Take green from your paint supply, go directly to the paper and let the stems and blossoms mix on their own.

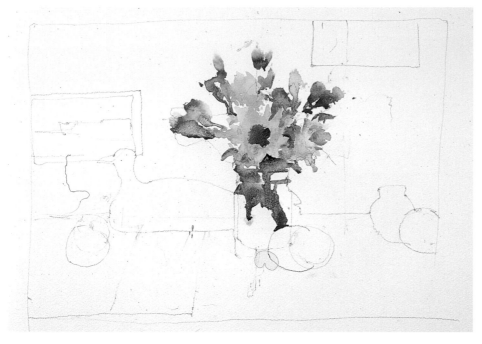

3: The sunflower is practically dry as you add Burnt Umber for the dark center. It's best if the flower isn't completely dry to avoid a very hard edge. Use lots of paint and very little water for this dark center. Otherwise you'll lose control. You don't want the umber flowing out into the flower. Find some petal shapes with your Olive Green and paint down to the lip of the jar. You don't want to isolate the flowers completely from the vase, but you do want some definition in the jar top. Carefully paint along the dry white paper jar lip, working from right to left, then paint down into the jar with Raw Umber and Olive Green. Be sure to paint the umber and green next to one another, but don't mix them on the palette. Save a few bits of white paper in the upper part of the jar.

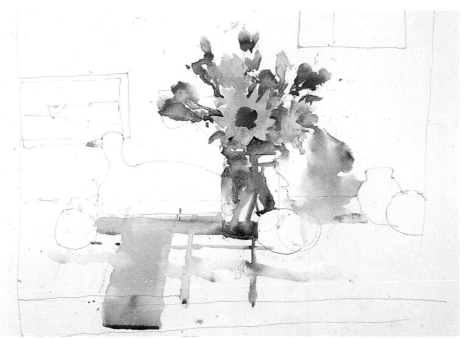

4: The shapes of dry white paper are necessary in the vase. They isolate the wet paint in the stems, giving them shape and pattern. Add a dark base in the jar with Cobalt Blue and let it flow to the left to start the pattern in the cloth. Paint the tablecloth with diluted Carmine and Cobalt Blue. Never mix diluted colors on the palette; instead, add water to each color in separate sections of the mixing area. If the values are similar, let them mix on the paper. Dampen the paper near the flowers with clear water. Start with semidiluted Cobalt Blue on the top of the cast shadow and diluted Raw Sienna at the bottom where the shadow works into the tabletop. Allow colors to mix in their own way. Carefully paint the pattern on the cloth on dry paper. Then make perpendicular strokes to soften and lose parts of the pattern. The folds in the cloth keep the design looking definite in some places and fluid in others.

5. Add another green next to the right side of the sunflower to get more definition. Unfortunately, it slightly isolates the sunflower. I could have lifted out the offending dark with the tip of a damp tissue or even bridged the gap with some opaque yellow, but leaving it makes a better visual lesson. You'll have to paint the coot decoy with one try following the instructions of pages 20-25. Make sure you have fluid Ultramarine Blue, Ivory Black and Burnt Sienna on hand.

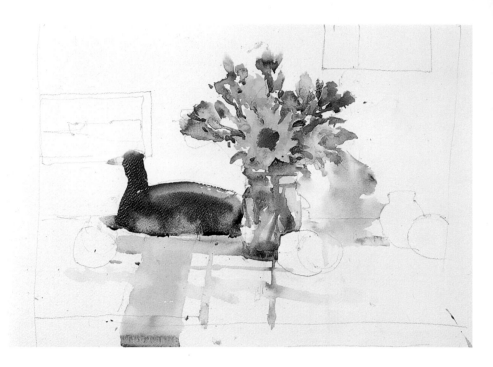

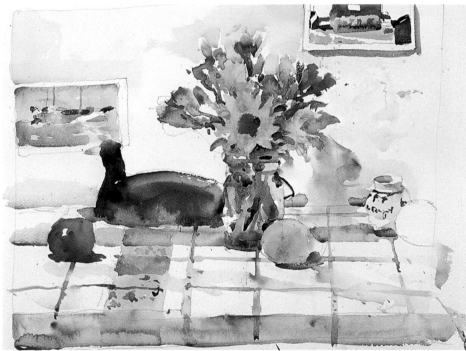

6. Use Cadmium Red for the apple and Cadmium Yellow and Cadmium Yellow Light for the lemon. In the light area, shapes of negative adjacent background darks butt up against the positive object lights with firm edges. In the shadow, darks forming the cast shadows are painted while the objects are still wet, making softer edges.

The shadows inside the top and under the lip of the mustard jar have the most contrast where they meet the light. In the top of the mustard jar, the shadow meets the front edge. There is also shadow in the far side meeting the wall. Make sure the part of the jar closest to you draws more attention. Darks and strong value contrasts come forward, while lighter values and weaker value contrasts recede.

The postcards by Winslow Homer and Edward Hopper help fill an empty background. Add some darks and cast shadows to the cards. If you need a cool color, just paint the cast shadow blue. If you need a warm color, paint the cast shadow orange and Raw Sienna. Use your cast shadows as color and value accents.

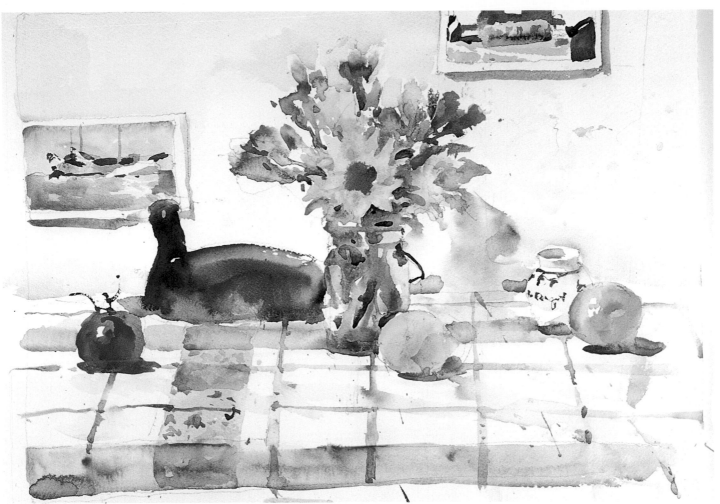

7. Paint the green apple with Cerulean Blue and Cadmium Yellow Pale with a Cobalt Blue cast shadow. Notice that everything in the painting should be connected. There are no isolated objects.

A Sunflower With a Mixed Bouquet
Watercolor on Fabriano Artistico Rough
 140-lb. (300gsm) Paper
10" x 14" (25cm x 36cm)
Courtesy of Munson Gallery

connect your paintings

Almost everything in your painting should be connected. A good rule of thumb is: 80 percent connected with 20 percent of the objects isolated.

iris and fruit

Now try this step-by-step demonstration
of an iris and assorted fruit.

colors

Cadmium Red • Cadmium Yellow
Cadmium Yellow Light • Cadmium Yellow Pale
Carmine • Cerulean Blue • Cobalt Blue
Lemon • Mineral Violet • Olive Green
Raw Sienna • Ultramarine Blue

brushes

Nos. 6, 8 and 10 round sables

contour drawing

I hope you notice that I've used more out-
side boundaries than I should have. I
wanted to keep this drawing simple, but I
should have lost more boundaries in the
vase and fruit. My boundary on the shadow
side of the vase shouldn't be as definite as
the boundary on the light side. I often use
less pressure on my pencil when drawing a
boundary I want to see but don't want to
stress in the painting. The lines on the
undersides of the fruit should have been
lost. The fruits and their cast shadows
should have been one thought. There are
many things to think about when painting,
so your drawing should remind you where
you should soften or lose a boundary.

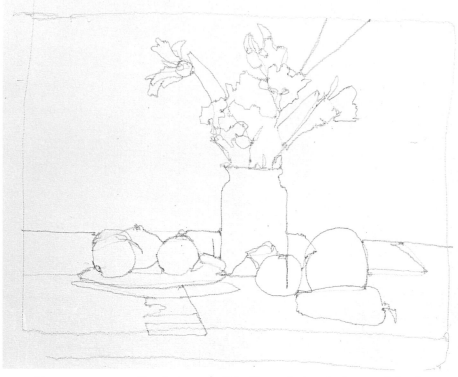

1. Draw your composition being mindful of boundaries, shadows and the shapes you want to create.

2. Load your brush tip with Mineral Violet and place it at the base of the iris blossoms. Carefully paint around and up from the dry white flower. Always start your stroke where you want a darker value or where you want a crisp, definite shaped edge. If you paint toward the white flower, you'll probably get a fuzzy, clumsy shape in the flower. Lift the brush in the midsection of the iris and place the brush with renewed dark violet for the darker upper petals. Remember your brush work: Point, press, and lift.

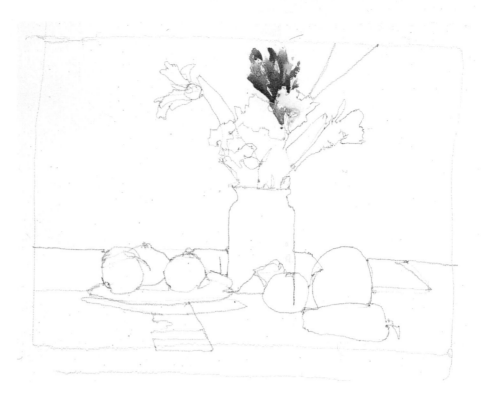

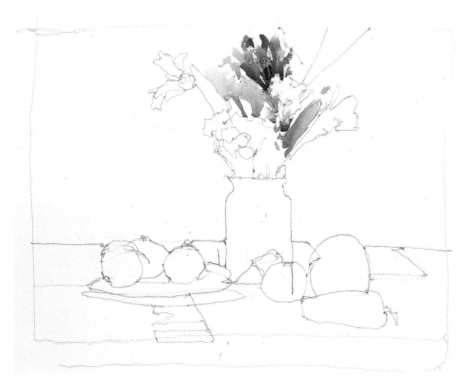

3. The iris is still wet so leave a very narrow strip of dry paper as you paint the yellow flower. Start the Olive Green leaf stroke at the carefully shaped white flower. Press the brush, then lift slowly as you form the lighter, upper part of the leaf. The hardest part is achieving delicate expressive shapes in the blossoms and controlling values and edges with your brush. This brush work is akin to oriental brush painting, where every stroke expresses an idea.

firm edges

If you want a firm edge in any part of a wet flower, leave a very narrow barrier of dry paper. If you want colors to blend, paint one wet flower or green right up against the adjacent flower or green. Always add the stems wet-in-wet to the base of the blossoms so that the colors connect and create unity.

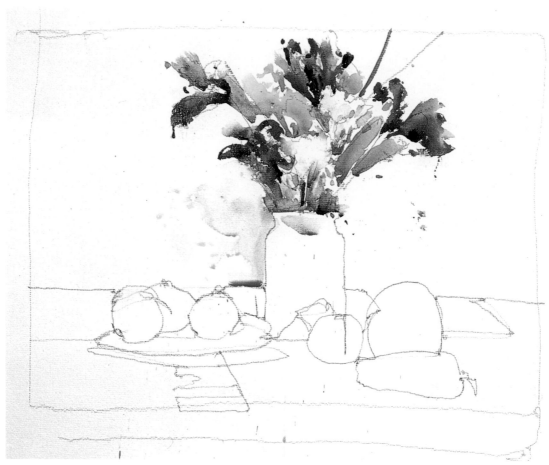

4. Using the techniques described in steps 1 and 2, finish the bouquet. You should be able to see where you begin stokes, where you hold firm edges and where edges blend. Start the shadow on the front of the vase where it meets the light with a firm edge using Cerulean Blue. Use very diluted Cerulean Blue in the background. The stems should still be damp and mix slightly with the blue.

5. Soften the shadow on the round vase with very diluted Raw Sienna and allow it to mix on the paper with the blue. The warm Raw Sienna will give a color temperature tie-in with the apple. You want the light side of the tomato to be rich, so start with Cadmium Red. Remember to start your stroke where you want emphasis.

Start the pattern in the tablecloth with diluted Mineral Violet.

Paint the shadow side of the vase with a diluted Cerulean Blue and a little Raw Sienna background. Carry the Raw Sienna into the background on the right. Leave a hard edge and a subtle contrast between the vase and background on the light side and a lost edge and no contrast on the shadow side of the vase.

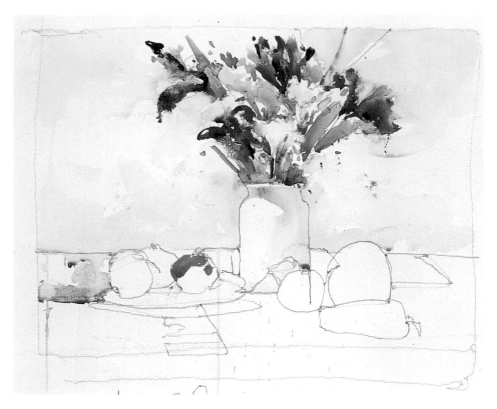

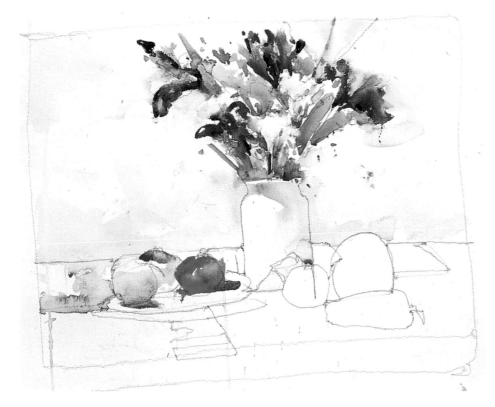

6. Finish the tomato and add a Cobalt Blue cast shadow wet-in-wet. There are two small white onions with a red Bermuda onion behind. Make sure that you don't mix the onion color with the tomato color. You want to keep the essence of whiteness in the onions. Paint the onion on the left with a very diluted Cerulean Blue. Paint a diluted Raw Sienna cast shadow next to the onion's bottom. Allow the two colors to blend on their own. The red onion is Carmine and Cerulean Blue. This darker shape brings the top of your white onion into focus. When the tomato is dry, paint the middle onion with Cerulean Blue and Cadmium Yellow Light.

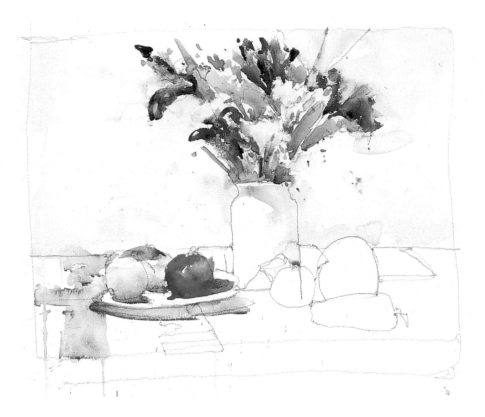

7. Paint the shadow and cast shadow under the plate with two strokes. You'll need a no. 10 round sable to manage this in two strokes. Starting at the left, paint the rim of the plate with semidiluted Raw Sienna. When the rim is completed, rinse, shake and load the brush with semidiluted Cobalt Blue or Cerulean Blue. Starting at the left, point and press the brush to its midsection. The lower part of the brush makes a firm lower edge for the cast shadow. The top part of the brush runs along the still-wet rim. If you can manage these two strokes quickly, you'll get a blend and some of the Raw Sienna will merge with the blue. The darker rim and darker cast shadow boundary help the lighter, midshadow/cast shadow to suggest reflected or bounced light.

8. Add the pattern of the tablecloth using Carmine, Mineral Violet and Ultramarine Blue. Never paint a pattern into a wet paper. When you add a pattern it should be painted on dry paper and then softened in places to keep it from appearing rigid. Patterns should be watery but definite in places. Always vary the values in your patterns.

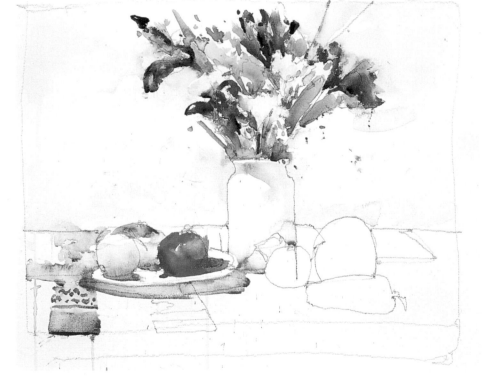

fixing mistakes

The red bled more than I'd wished. The tomato was probably too wet and lacked Cobalt Blue pigment in the cast shadow, which was also too watery. If this happens to you, do not blot with a tissue. The best thing to do is to correct wet-in-wet with undiluted blue paint starting at the base of the tomato. (There's already enough water under the tomato.)

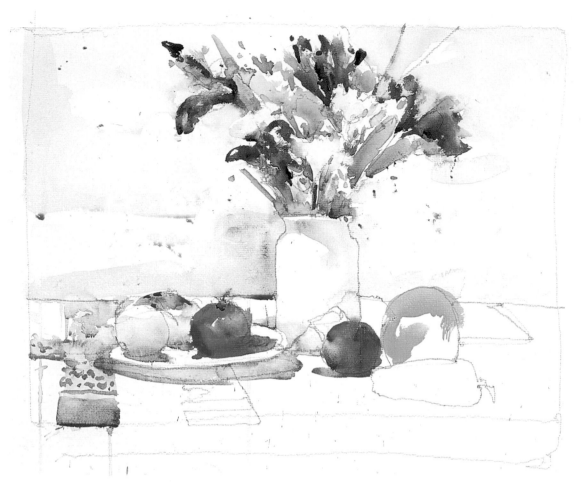

9: Add the other tomato under the vase. The upper part of the tomato has a hard edge with intense color. Lose the edge as you go down the left and light side of the tomato. Tie in the midsection of the tomato to the bottom of the vase by letting it soften and blend with the vase's bottom boundary. The cast shadow under the tomato is Raw Sienna. You don't want to repeat the cool cast shadow under the plate.

Start your grapefruit with Cadmium Yellow straight from the color supply with only enough water to keep your yellow fluid and workable. Always start your fruit on the light side so you keep strong local color. Never paint washed-out and vapid colors in your light areas.

colors for cast shadows

Students ask what color to use in cast shadows. I never paint what I see since most cast shadows look a neutral gray. You have to make up a color that suits the painting. Cast shadows make great color notes, so choose a color that suits the painting. Don't ever use a generic puddle color in any part of your painting. Cast shadows need to be rich and flavorful and always fresh. Check the colors you've used in an adjacent object and cast shadow. You don't want to repeat the same color idea, so vary the ratio and preparations of three colors: blue, red and yellow. Choose a blue for its value rather than its color. Choose Cerulean Blue for light areas, Cobalt Blue or Ultramarine Blue or Mineral Violet for dark areas. For red use Carmine or Alizarin Crimson (Cadmium and other opaque reds don't make good mixers). For yellow use Raw Sienna because it's so quiet and never dominates. I also use Cadmium Yellow but it's assertive.

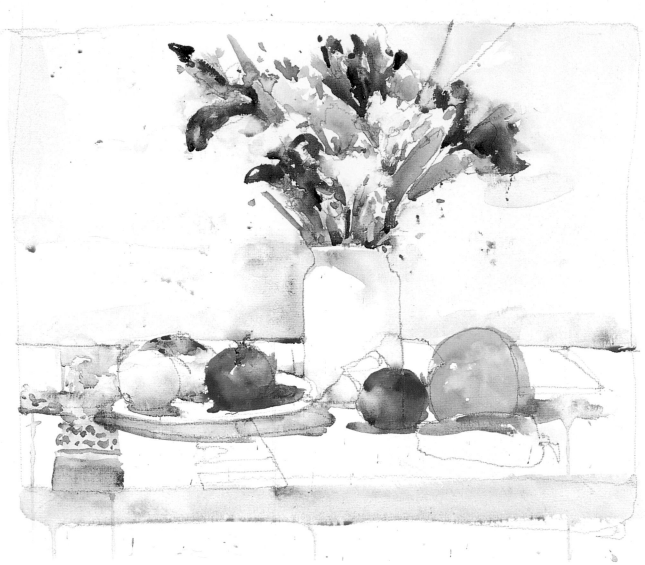

10: Paint a strip of a slightly darker value to show the table edge. Use any diluted blue with Carmine/Alizarin, any yellow or Raw Sienna. Just make sure you mix the colors on the paper. Use plenty of paint and enough water to achieve your value. Complete the grapefruit. Don't try to show light and shadow. Stress the inherent value and color in fruit and flowers and make form (light and shade) secondary. Add the Cobalt Blue cast shadow. Paint the green pepper, starting with the top and light side. The yellow grapefruit and the Cadmium Yellow Light mixed with Cerulean Blue in the pepper are compatible, so you can paint the top of the pepper when the grapefruit is still wet. A blend between the grapefruit and the pepper would be fine here.

creating visual unity

Always connect the objects in your painting with adjacent objects or the background. There's a tendency to paint an object really well and completely and then go on to the next thing. Don't do this. Instead, paint parts of your subject with exquisite care for shape and crisp edges (usually out in the light but not always), then lose and blur other parts.

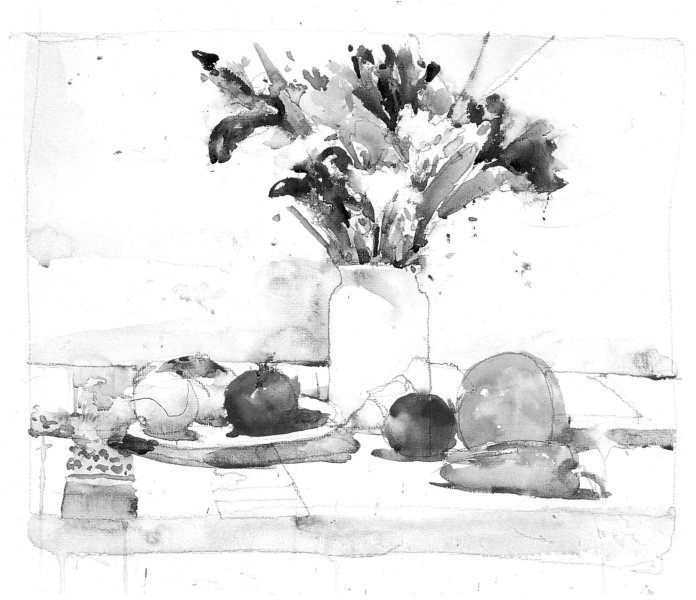

11: Finish the lower part of the green pepper with a mid-value green of Cadmium Yellow Light and Cerulean Blue, leaving bits of dry white paper. Paint a dark blue cast shadow under your pepper. Doesn't the rich cast shadow make the pepper luminous?

Iris and Fruit
Watercolor on Fabriano Artistico Rough 140-lb,
 (300gsm) Paper
12" x 15" (30cm x 38cm)
Courtesy of Munson Gallery

paint color and value

You can ignore light and shade when you're painting dominant colors and dark values. Don't stress dark shadows in a fruit or flower; instead, paint their interior color and value. Hold a pepper or any fruit in your hand. Study it briefly. Close your eyes and then write your color and value impressions of the pepper, grapefruit or tomato. You'll probably remember the true color and value of your object. Paint the color and value you remember. Darks in shadow should never destroy the object's "lightness of being." Dark cast shadows are a wonderful way to enhance the true color of your objects. Never be bound by rules. No good painter follows rules. They are only meant as signposts.

KITCHEN FLOWERS

I've always enjoy painting our kitchen counter or table with a window view in Connecticut or Nova Scotia. I'm not an inspired landscape painter but like to include the view through a window in my still lifes. I need something in the foreground to excite me. I like to set a vase of flowers down with fruit and kitchen items casually arranged as if we've just come back from shopping. I don't carefully arrange the fruit, pots and flowers at first. I want an appearance of casualness. Then I check the placement of my strong colors and dark values. Remember that the placement of objects isn't important; it's the placement of colors and values that counts. For this painting I have a very colorful flower arrangement. I'll need some darker values and strong colors on the

countertop. (It would be a good idea to review the demonstration for backlighting, pages 100-103, since we have a similar situation here.) I want to keep my window frame luminous without having the upper part of the painting appear weak. This means that I'll have to stress some of the darks in trees and cast shadows on the snow. Let's assume you have white or light-valued colors in your window frames and some dark-valued trees or buildings outside your window. First squint and you'll see that the window frame appears darker than the trees or buildings. Open your eyes and focus on the trees or buildings. Hopefully the window frame will appear lighter in relation to the distant darks. I've painted the distant trees and shadows with my eyes wide

open. I've used color changes with close values in this painting. This is difficult. If you have trouble controlling your values as you make color changes, you should forget the color changes and deal with them when you have a bit more practice. Values are more important than color, so if you can't keep close values in the window frame and tiles, use puddle color. Color changes are nice but not essential.

colors

Burnt Umber • Cadmium Orange
Cadmium Red • Cadmium Yellow Light
Carmine • Cerulean Blue • Cobalt Blue
Ivory Black • Mineral Violet • Olive Green
Raw Sienna • Ultramarine Blue

1. Complete your contour drawing. The red flower has large petals with white toward the black center. Don't fill in the flower as a solid shape. Use plenty of Cadmium Red but leave some whites and some blurs. This helps keep softness in the flower. Later you can come back to the white petal and add some lighter red. Paint the Olive Green when the flower is damp. Once the flower is dry add the Mineral Violet in adjacent flowers.

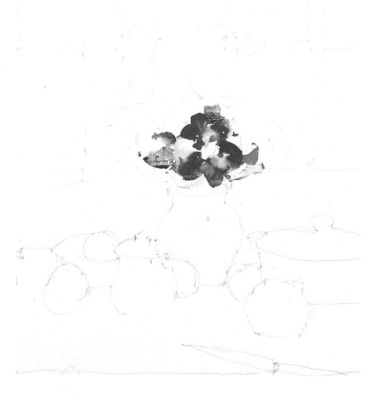

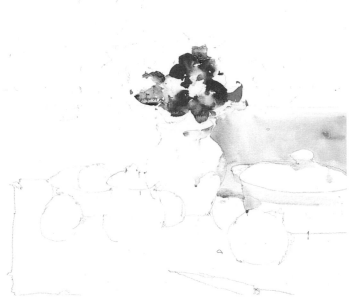

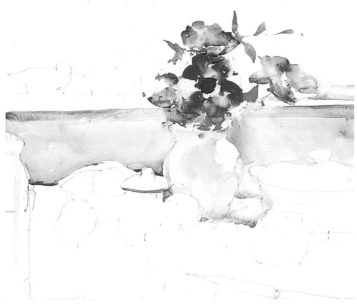

2: Do not paint the shadow on the white vase too dark. Keep the essence of white and still give the vase form. The sun hits the upper right section of the vase, so keep some dry white paper. Paint the vase with Carmine, Raw Sienna and Cerulean Blue. Carry these colors out into the background on both sides of the vase. Keep a hard edge where the white area meets the background, but soften the white where it meets the vase's shadow. This helps the vase to look round. Keep a hard edge where the background meets the countertop and the top of the casserole dish. Use the same colors in the cast shadow at the vase's base. Remember not to mix the Carmine, Raw Sienna and Cerulean Blue all together on your palette. You want to mix separate ratios of the three colors for each section.

3: Paint the sill on the left first, starting the stroke at the right boundary of the painting. As you approach the flowers, the sill lightens. Let it dry as you add some more Mineral Violet flowers. The tiles between the countertop and sill must be painted without stopping since you want a single value. Use the same three colors but use more Raw Sienna to the right of the vase, more Carmine near the right picture border and more blue in the tiles on the left. Paint the tiles in one stroke and keep your values as close as possible. Paint the top windowsill while the tiles are still wet. The top boundary of the sill and base of the tiles should have your darkest values. Shadow is always darkest where it meets the light.

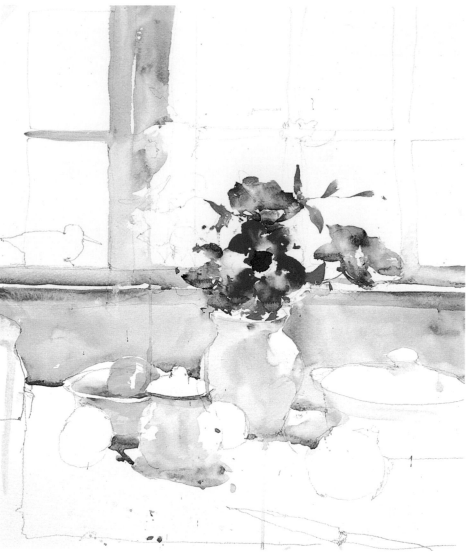

4: Paint the lemon using Cadmium Yellow Light. Use Carmine, Raw Sienna and Cerulean Blue in the bowl, small pot and window frames. Allow the Cadmium Yellow Light from the lemon to drip over the rim of the bowl. Release some lemon color into the bowl. Use Cobalt Blue for the shadow under the bowl. Paint around proposed flowers in the window frame. Do not paint the window muntins mechanically. Vary your values and edges even if you have trouble with color changes. Paint the leaves and stems with Olive Green and a no. 6 brush. Remember your brush work: Tip, press and lift with your brush.

changing sunlight

When I'm painting a still life in direct sunlight, it's necessary to finish the still life with changing shadows and cast shadows in one sitting before going on to the background. The next day may be overcast. You can't fake it. In other words you can't paint part of your still life in direct sun with changing shadows and cast shadows and finish it successfully on a cloudy day with flat lighting. I'm painting this painting on a bright day but the sun isn't on my subject. It's a good light but a passive light that only makes subtle shadows around the base of my objects. Since I'm not racing the sun I can leave my still life and work on the view outside through the window.

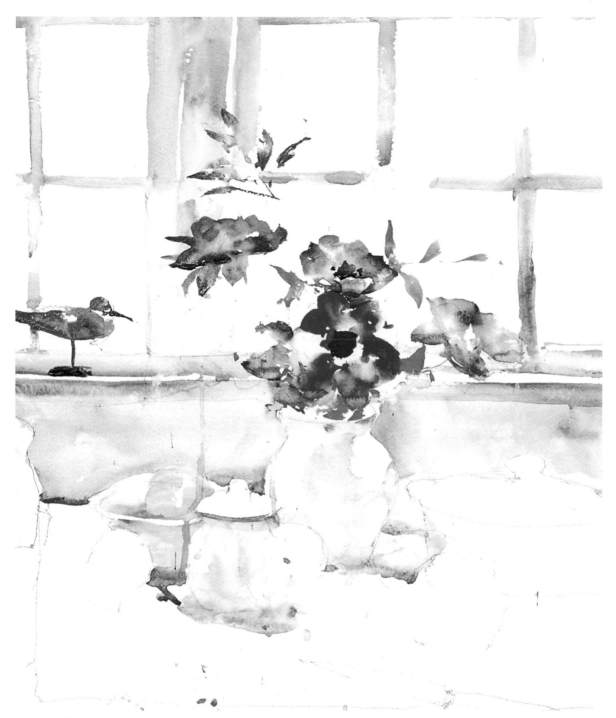

5: Add more purple-blue flowers using Mineral Violet, Ultra-marine Blue and Carmine. Use Olive Green in the leaves. Think of a flower as a color swatch with shape. Let your colors blend on the paper with just enough water to let the colors move and mix.

The little shore bird adds a dark, helping the viewer's eye move away from the dominant flowers. Use Olive Green, Ultra-marine Blue, Raw Sienna, Burnt Umber and Cadmium Orange for separate parts of the bird. Make sure to leave a bit of white paper to separate the head from part of the body.

squint to define contrast

Place a red apple to the right and behind a light-valued pot. The light source should be above or to the right of your objects. Squint very hard and look away. Decide where you recall the strongest contrast.

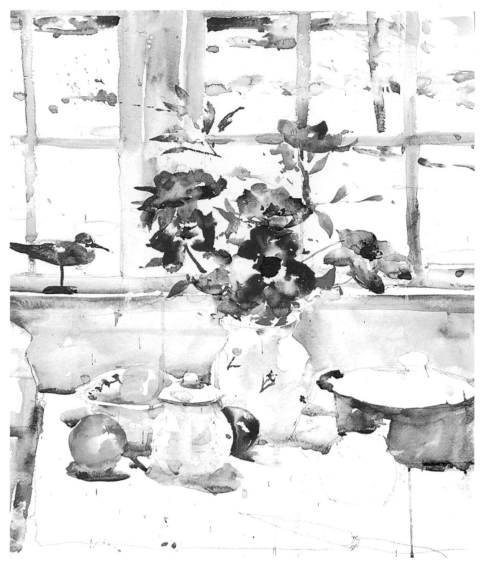

6: To give the top of the painting some strength, you'll want some dark values and clear color. You can cheat and use a pure color when you really only see a dark. Paint Ultramarine and Cobalt Blue with some skips and lost edges beyond the window at the top of the painting. Use Cadmium Orange and Raw Sienna to paint the dried grass showing through the snow. Try not to be literal when you're choosing a color. Don't mix a generic dark. There are strong and pure colors in the still life so it needs strong pure color in the background.

Lift the yellow drip on the bowl with a tissue tip and water. Paint the left rim of the sink with Cobalt Blue and Ivory Black using lost and found edges. Leave highlights of white paper in the apple, orange and lemon. This is an easy way to give the fruit form without using light and shadow. The red apple defines the side of the pot with a firm edge but softens as it reaches the vase. If you make all the boundaries definite, the apple will be isolated. Follow the same principle for the blue casserole dish. The darkest parts in the casserole are next to and define the white onion. The casserole is mostly Cobalt Blue with a bit of Carmine. The lower left cast shadow is Raw Sienna, which blends into the casserole.

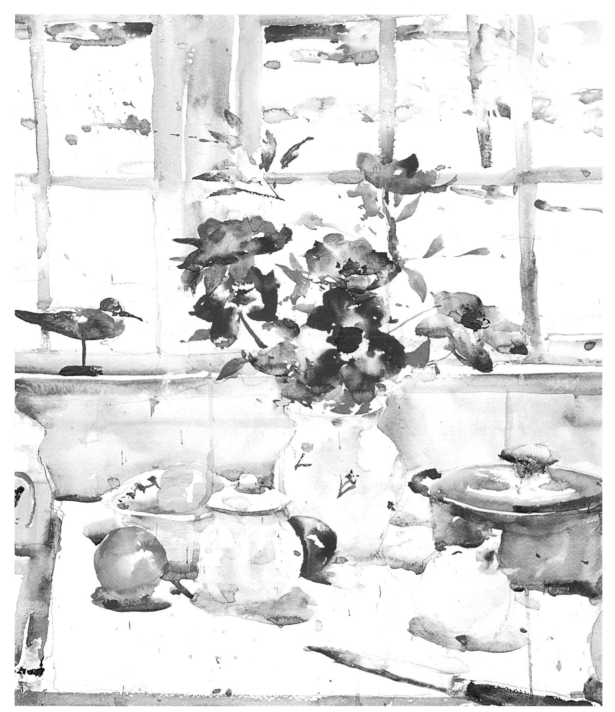

7: The white onion is very white, so rather than losing the whiteness with a dark
 shadow, make the cast shadow dark. There's some Carmine in the onion's stem
and a very diluted wash of Carmine and Cerulean Blue in the onion and Cobalt Blue in
the cast shadow. Paint the cover of the casserole so that it fades into the back wall with
lighter values. Paint the handle in Ivory Black, leaving dry white paper for reflections.
The front rim is the darkest part.

Notice how the knife leads your eye into the painting. Paint the handle Ivory Black
and Cobalt Blue. The knife tip and cast shadow under the blade are also Cobalt Blue.
Paint the trim on the counter Raw Sienna with a bit of Cobalt Blue.

Add a grapefruit with Cadmium Yellow Light and a Cobalt Blue cast shadow in the
lower right corner.

keep techniques consistent

Don't paint part of your picture with hard
edges and other parts with blurred edges.
I've used lost and found edges in the flow-
ers so I keep the same approach through-
out the painting regardless of the nature of
the thing I'm painting.

Narcissus and Golden Eye—Painting Negative Shapes

I've arranged a small bouquet of narcissus from my wife's, Judy's, garden and placed them in front of a Whistler decoy. The hardest part of painting is getting into the right side of the mind, away from the flower's exquisite delicate detail. Instead, the flower must become a shape of light against some darker shapes, greens in the leaves and nearly black in the decoy's markings. This sounds cold. Sadly, to make art, something expressive of yourself, you must first develop your craft. You need to see. You need to understand what you're seeing and then simplify. You can't copy nature. Instead, copy value shapes of light and dark. Don't worry about what color you should use. Your art will follow.

colors

Alizarin Crimson • Burnt Sienna
Cadmium Orange • Cadmium Yellow
Cerulean Blue • Cobalt Blue • Ivory Black
Lemon Yellow • Olive Green • Raw Sienna
Ultramarine Blue • Yellow Ochre

brushes

Nos. 8, 10 and 12 round sables

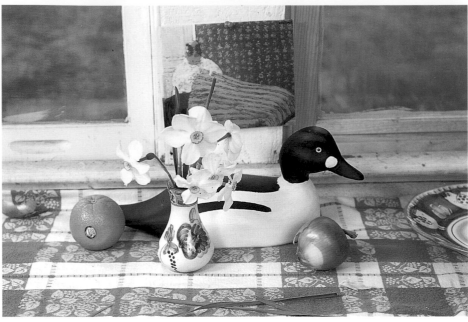

Setup—Photograph

My set up contains a postcard by Edouard Vuillard, a Whistler decoy, a small patterned vase, an orange and an onion. I forgot to remove the label on the orange and decided to change the onion to a lemon—thinking the lemon would be an easier and a more obvious color note. For simplicity's sake, I haven't used the windows or tablecloth.

All photos of subjects will lack light and shade and cast shadows. They don't show up in artificial light.

painting a delicate white flower

Have some obvious darks around the flower and paint these darks (negative shapes) *before* you paint the white flower. If you try to paint a light-valued flower on white paper, you'll overwork it and make it too dark and fussy.

1. Draw your subject. (If you skipped over the contour drawing section [pages 46-47], make sure you understand this drawing.) You must be able to make a cogent single-line drawing. If you are lifting your pencil constantly, using many sketchy lines and erasing, you'll make a mess of your paper and make a confused image. You need a single, expressive, definitive line for painting.

2. Always work from your paint supply, not from dead puddles on your palette. Puddle color is only good for wiping up, not painting. Complete the top window frame with slightly diluted Raw Sienna in one pass, with the point of a no. 10 round brush placed along the bottom edge. Press the "sweet" part of a sable brush—up near the ferrule—lightly but firmly into the paper. Make a single stroke. Don't dab or bother it. Repeat the same stroke for the lower window frame after adding a bit of Cobalt Blue to the small mix of Raw Sienna on the palette. Use Olive Green for the stems. What green you use isn't as important as getting the right value and being able to make single upward strokes, feathering off at the upper tip.

3: The darker greens in the leaves aren't solid, flat cutouts. Add color wet-in-wet, allowing the Raw Sienna and the Olive Green to mix themselves on the paper. Be careful to leave some of the petals dry for crisp edges on the upper parts of the big flowers while dampening some lower petals with just a haze of Alizarin Crimson and water before adding the darker green background. Add a touch of Cadmium Yellow in the flower's center. Mine bled too much but I left it alone. The lower half of the postcard is diluted Alizarin Crimson and Cadmium Orange accented with a mostly pigment strip of Ultramarine Blue brushed along the bottom, wet-in-wet.

4: There's fading in the Alizarin Crimson and Cadmium Orange section of the Vuillard postcard. All middle or light colors will lose value and color as they dry. Never think that what you paint will stay the same in these lighter value ranges. Add some definite darks—the decoy's head and the dark in the postcard. Use Ivory Black and Ultramarine Blue in both. The key is to use lots of paint and a good deal of water. Go for the dark with your first shot and don't plan on over-painting. As soon as you paint the decoy's head, add some Cobalt Blue behind to tie into the background. Don't leave a dark positive shape isolated without some connection with its surroundings.

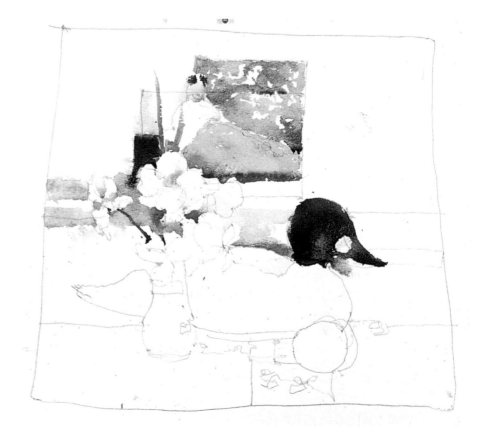

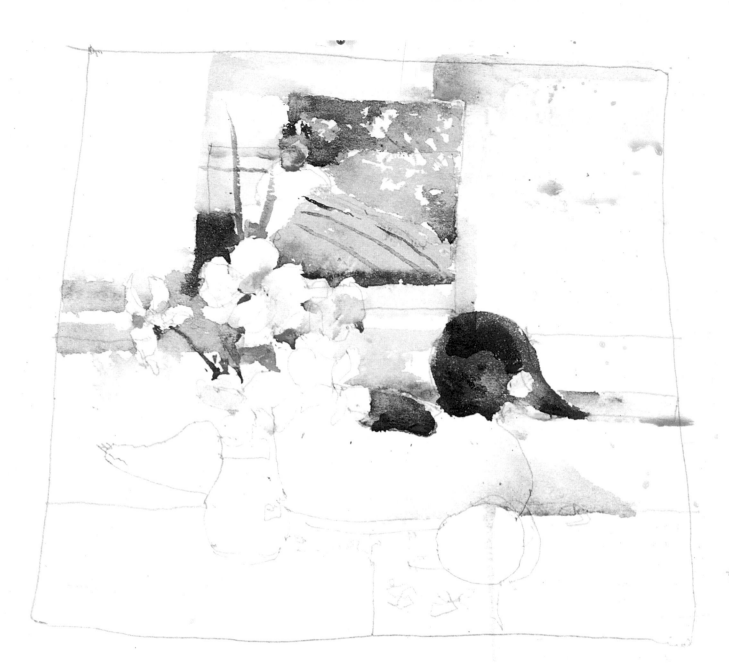

5: While the Cobalt Blue negative shape you added in step 4 is still wet, add the dark marking on the decoy's back with Ivory Black and a little Burnt Sienna. Start your stroke on the lower side of the marking, and with a single stroke, brush up to the Cobalt Blue negative. There's enough dampness in the Cobalt Blue mixture to cause a lightening in the upper edge of the marking. Use a water wash of Cerulean Blue to suggest a shadow on the decoy's breast. Continue it out over the boundary of the decoy to form a cast shadow. Drop in a touch of Yellow Ochre at the boundary. Note that the cast shadow has hard edges. Add another strip of Cerulean Blue and watery Yellow Ochre in front of the bill. It's important to remember to mix these colors on the paper—not on the palette. If the decoy's head is not dark enough, you will need to add Ivory Black when the first wash is dry.

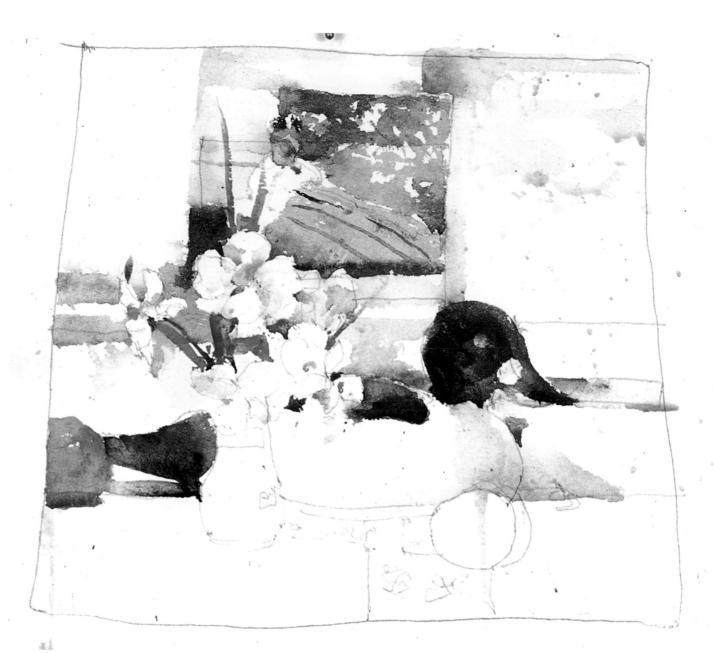

6: Paint the tail with Ivory Black, Ultramarine Blue and a touch of Burnt Sienna. These darks aren't solid but have subtle value variations. They are slightly lighter on the duck's upper back and as they reach the flowers and orange. This helps avoid the cutout-and-pasted-down look. Do this by using a bit more water in the initial statement and then immediately, while the dark is still wet, adding more of the Ultramarine Blue or Burnt Sienna, with almost no water (you probably wouldn't add more black). Paint the dark negatives using Cobalt Blue, softening some edges before the Cobalt Blue dries. Add the orange using Cadmium Orange and a cast shadow of Cobalt Blue (very little water with the blue) while the orange is still wet. Add a little Cerulean Blue to darken the orange. Add a bit of Cadmium Yellow and Yellow Ochre at the top. Start painting some very light monochromatic gray filler areas. This sort of thing can cause your painting to get overworked and dull looking so be careful. When in doubt, avoid adding tones like these, instead leaving the white paper alone.

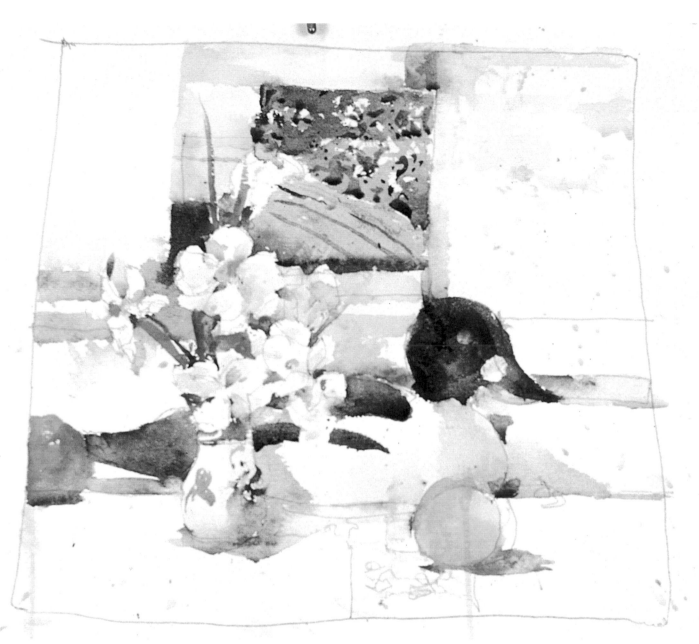

7. Try to do as little detail in the flowers as you possible can. So many students "love their flowers to death," trying for the lovely nuances. Lovely nuances are only possible if you have complete control of value. It's like having perfect pitch in music. Most of us lack complete control so keep it simple. Learn good edge control. Be able to see and paint hard edges and know where and how to soften and lose edges. Rely on darker negative shapes whenever painting light-valued flowers.

Add some Cadmium Yellow and Cadmium Orange in the narcissus centers. Use Ultramarine Blue and Burnt Sienna to paint the pattern in the upper part of the vase and a dark stripe in the decoy to set off the remaining flowers. In the vase, make a shadow and cast shadows over to the decoy. Notice that shadows and cast shadows are always a single thought, not two separate thoughts. Add pattern to the lower part of the vase. Paint the lemon using Lemon Yellow and add its cast shadow wet-in-wet. Use Cerulean Blue under the lemon and in the cast shadow below the vase.

Narcissus and Golden Eye
Watercolor on Shut Flamboyant Rough 140-lb.
 (300gsm) Paper
12" x 13" (30cm x 33cm)
Courtesy of Munson Gallery

A WINDY AND SUNNY DAY, ARIEL SANDS, BERMUDA

This painting was a demonstration for a class in Bermuda. Bernie Martin, one of the students, took pictures as I painted. The sun was so bright that some of the steps are a bit lighter in color and value than the finish, which was taken in a studio. In direct sun, I always use an umbrella. It's a problem with a breeze, but it's necessary. Sun on paper is bad for the eyes and makes judging values impossible. I never paint with sunglasses. They deaden the values and colors.

colors

Alizarin Crimson • Antwerp Blue
Cadmium Orange • Cadmium Yellow
Carmine • Cerulean Blue • Cobalt Blue
Lemon Yellow • Mineral Violet (Holbein)
Olive Green • Opaque White
Peacock Blue • Viridian • Winsor Blue
Yellow Ochre

brushes

no. 10 round

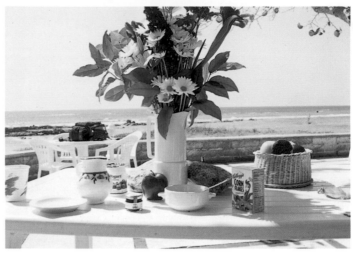

Setup—Photograph
This was taken from my chair before I started painting. The wind hadn't come up yet. I raised the table in my painting so I wouldn't have to deal with the wall, table and chairs. Simplify whenever possible. The wall and the grass beyond made a complicated and unnecessary problem. I used a rock next to the windblown vase, hoping to support it.

1. Complete your contour drawing. Working outside with the wind and light changing requires a speedy and concise drawing. There's no time for tentative sketching. Cast shadows are included with some of the objects. Notice the correction line on the vase. Don't correct; use your mistake to guide you for a better boundary.

2. Start with a middark value. Don't plan to overpaint. There's no time. Make it rich, not a gray, watery mix from your palette's mixing area. Go to your paint supply. Use Winsor Violet or Mineral Violet and Cobalt and Ultramarine Blue. Don't think a lot about what color you use. Your brush should go to darks—blues, greens, Olive Green for my stems and unopened iris. Think more of what value you want.

Do a bit of watery Cerulean Blue sky. When it is dry, start with your dark blues, violets and greens. Get a good rich color value. That's the game. Press, lift the brush with the handle at a 45° angle, stroke up with little finger on paper (Check Brush Work, pages 16-19).

Take a Closer Look

Here's a close-up detail. Since I work with the sun, I finish parts and don't plan on returning, remembering that the flowers will dry lighter. Its better to enrich with color wet-in-wet now. Don't do a weak flower and think you'll fix it later. Sometimes you start the stroke at the base of the petal; sometimes you start at the petal's tip and paint toward the base (look at the leaves and flowers, begin your stroke where you see the darkest color-value). Think of placing strokes as spots of color. Think of Oriental brush work. Each stroke must have good water-paint consistency. Press the brush's midsection into the paper, then lift with a feathering stroke.

<div style="background:gray">watercolor secrets</div>

Do as little brush work as possible. Let the water, paper and paint do the most work.

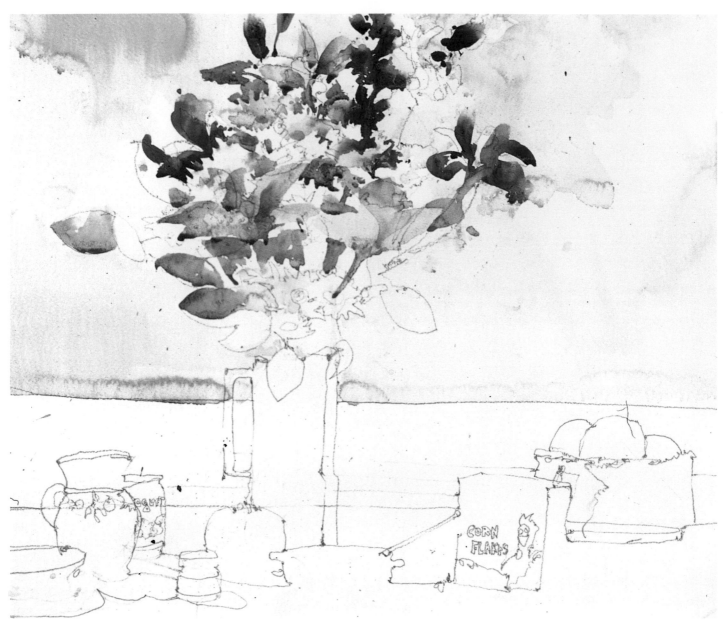

3: In some places, the paper will be dry. In other places, the paper will be wet. If needed, you can add water or paint in the background next to the flower you're painting. Paint the blurred iris on the right into a damp background. Paint slowly with decision. Make good careful shapes. See the careful way the Mineral Violet and greens are painted around the upper side of the daisies, Viridian in some places, Olive Green in other spots. (Don't mix greens together. Get in the habit of going to the paint supply and choosing different greens or blues.) Paint the daisy on the left with Mineral Violet. Some edges are firm. If you want a firm edge, wait for the dark behind the daisy to dry before adding the daisy's shadow shape with diluted Cerulean Blue and a tiny bit of Cadmium Orange mixed lightly with water on your palette. Paint the shadow shape and let it drift out of the daisy into the background. Add a touch of pigment, either green or blue, near the daisy. Let the diluted color from the daisy mix with the darker blue or green. Let them mix on their own; try not to interfere.

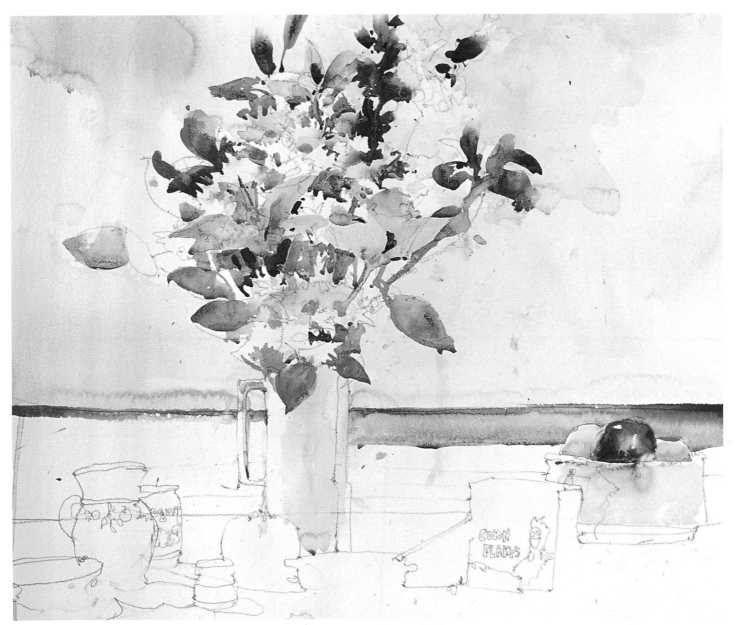

4. Paint the pink flowers with a diluted Alizarin Crimson or Carmine. Under the pink flowers, paint a section of green. Vary the values here. Don't fill it in as a solid mass or you will isolate the pink flowers from the daisies. Shadow shapes in the upper part of the daisies are important. The shadow shapes and carefully painted negative give the daisies form.

Use the ocean to define the vase. The shadow on the white vase should be very subtle and light in value. If it is too dark it will destroy the whiteness of the vase. Paint in some sky. Any very watery blue will do down to the horizon. Starting from the left margin, paint a stripe of Antwerp Blue or any dark blue. Make a single stroke up to the vase handle and then behind, all the way to the right margin. When the stripe is almost dry, add a more diluted section of Antwerp Blue on the right, up to and around the drawing of the lemons and apple.

Allow the water to dry. Paint the lemon with Lemon Yellow at the top and a bit of Cadmium Yellow at the bottom. When the lemon is almost dry, paint the apple with Alizarin Crimson, leaving some white paper for highlights, then add the lemon on the right. Dampen the basket so some apple color seeps down.

bermuda high

A high point of preparing for the class demonstration was the trip to the florist. We went on our motor scooter. Judy and a helpful young woman picked out the flowers. She trusted us with a vase. Then we were back on the scooter in impatient Bermuda traffic with Judy cradling the flowers in her arms. The flowers managed the trip and the demonstration day of wind and sun. They even had the courage to face two more mornings of painting. A boost of three roses was needed on the third morning when I painted Kellogg's Corn Flakes.

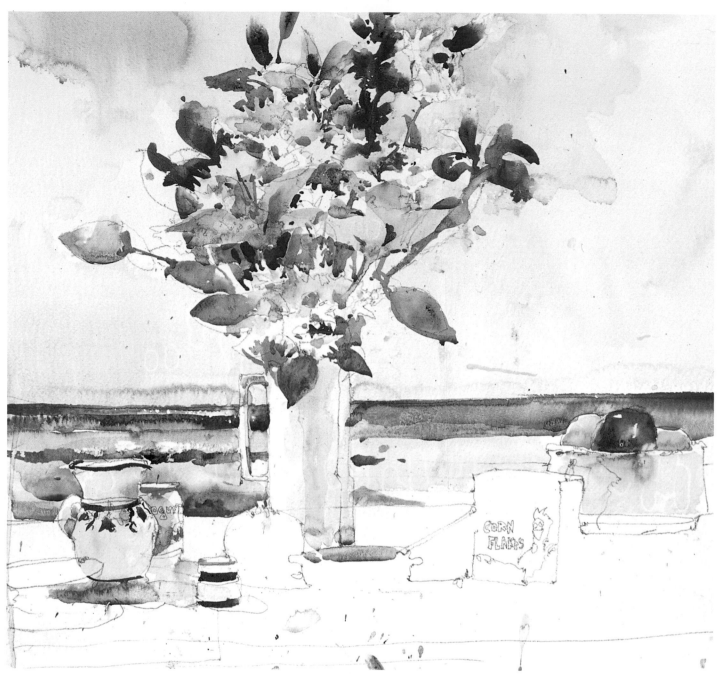

5: Paint the closer water with a diluted Antwerp or Peacock Blue. Leave some whites
above the rocks. There's surf with the strong breeze. Either scratch out whites with
a penknife or use Opaque White.

Add the Olive Green grass when the water is still wet. It's very important to keep the
sense of white in the vase, pitcher and yogurt container. Instead of shadows that might
gray and dull the white containers, use the designs and patterns in the containers for
your darks along with dark cast shadow shapes. You need to add rich definite small
darks while you're painting an object. If you add them later, they'll look added on and
out of context.

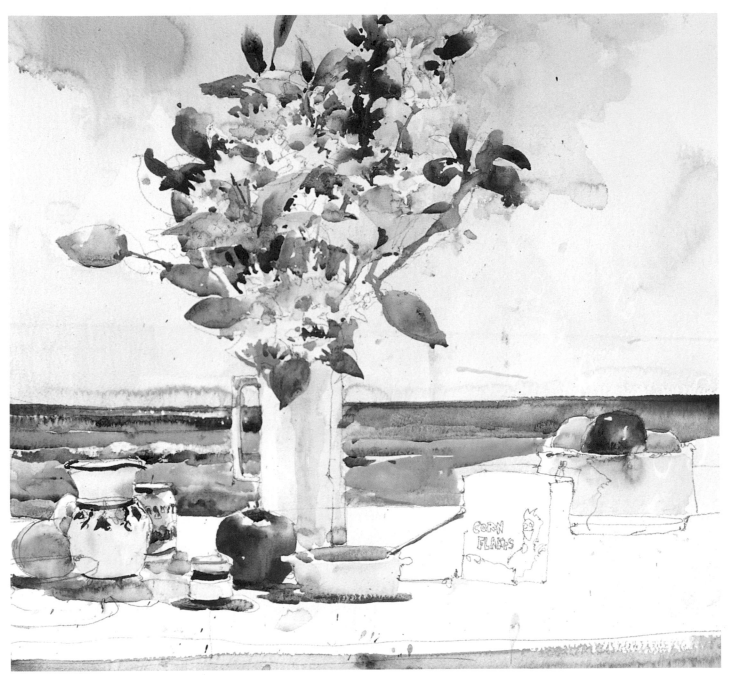

6: In the right foreground water, use Peacock Blue, a nice clean transparent color for shallow tropical waters. Winsor, Cerulean or Antwerp Blue could work here also. When the lemon is wet, add more blue cast shadow. Never paint an object without adding its cast shadow almost immediately. (The cast shadow can't be too watery. Use mostly paint, little water.) Paint the apple and orange, leaving white paper for highlights. When deciding what color to use in fruit, simply look at your palette's color supply and see what seems to match what you want to paint. Add a bit of dark blue wet-in-wet to the Alizarin Crimson in the apples. Add a bit of Yellow Ochre to the Cadmium Yellow for the lemon on the left.

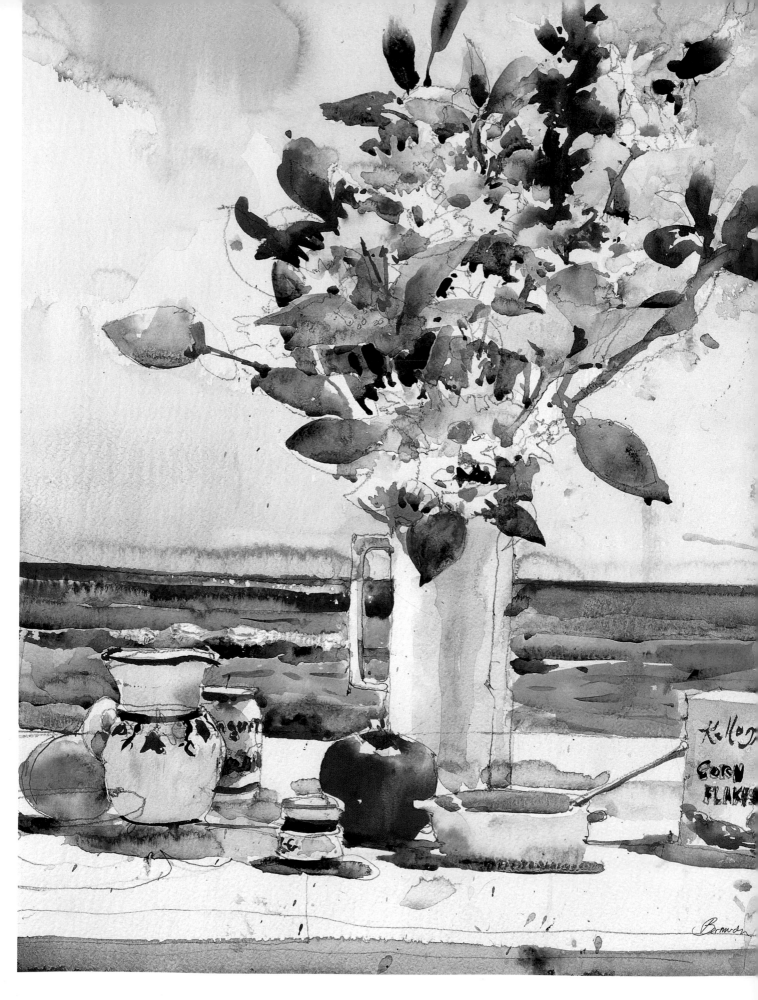

I spend so much time trying to describe to my students the colors I'm using. People think the picture will be good if they use the right colors. Usually I don't know what color my brush instinctively finds. During the Bermuda class, someone asked what I was using in the pink flowers. I was working on a particularly difficult section in the pink flowers, trying to get just the correct shape, edge and value. Marcia, who's been in many classes and understood my concentration, suggested to the student that she might try Permanent Magenta. I whispered, "Thank you, Marcia." Permanent Magenta would probably be better than my standard Alizarin Crimson for the pink flower.

More important than the right color is the right color value. When painting outside with strong sunlight, no matter how strong the sun, your darks must remain dark in the light and white objects must retain their whiteness in shadow.

Fruit should always retain its strongest color out in the light. Fruit in shadow should keep its color. The darkest part should be where light and shadow meet.

Cast shadows are often darker than the light-valued objects that cast them. Cast shadows should be rich and dark, not dense. They should have a feeling of light in them.

7. Add the orange and saucer on the far right. Add the Corn Flakes package and cereal bowl. Use diluted Alizarin Crimson, Cobalt or Cerulean Blue and Yellow Ochre for your light grays. This combination doesn't work well for many students. If you have a good gray, use it. The Corn Flakes' shadow value is dry when you add the lettering with a no. 3 round brush.

Kellogg's Corn Flakes and Flowers
Watercolor on Fabriano Artistico Rough 140-lb.
 (300gsm) Paper
20" x 24" (51cm x 61cm)
Collection of the Artist

conclusion

I hope you enjoyed this book and have learned much. And remember

"simplify...simplify."

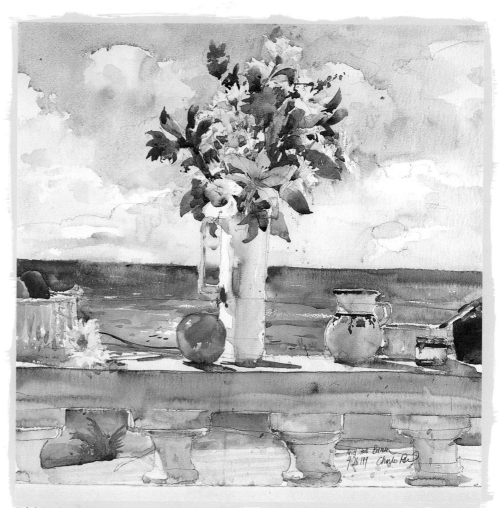

Ariel Sands, Bermuda
Watercolor on Fabriano Artistico
 Rough 140-lb. (300gsm) Paper
24" x 20" (61cm x 51cm)
Courtesy of Munson Gallery

suggested reading

Charles W. Hawthorne's *Hawthorne on Painting* (Dover Press Publications, 1938), Betty Edwards's books on right-brain thinking and Burt Dodson's *Keys to Drawing* (North Light Books, 1990).

index